The Chesapeake
Book of the Dead

The
Johns Hopkins
University Press
Baltimore & London

The Chesapeake Book of the Dead

Tombstones, Epitaphs, Histories, Reflections, and Oddments of the Region

Helen Chappell

Photographs by
Starke Jett V

Printed in the United States of America
on acid-free paper

2 4 6 8 9 7 5 3 1

The Johns Hopkins University Press
2715 North Charles Street
Baltimore, Maryland 21218-4363
www.press.jhu.edu

Frontispiece: Lower Hooper's
Island, Maryland

Library of Congress
Cataloging-in-Publication Data will be
found at the end of this book.

A catalog record for this book is
available from the British Library.

ISBN 0-8018-6041-5

Contents

Preface

If you enjoy walking through old cemeteries and exploring forgotten, overgrown graveyards, you may be relieved to find that you're not alone. A surprising number of your fellow Chesapeake citizens also enjoy this pursuit of our past.

There is a romantic, nostalgic, pleasantly melancholy feeling to old cemeteries that is hard to define but easy to experience. Perhaps it is because here we can feel the direct link to our past that no history book, no movie, no historical fantasy can ever convey. These stones and these unkempt grounds are the hard evidence of lives that came before us. Once, these people lived and breathed, loved, worked, fought, hoped and despaired, and experienced their triumphs and failures just as we do today. And, although we seldom care to acknowledge it, we will inevitably go where they have gone.

> Friend, as Ye Pass By
> See the place where now I lye
> As you are now, so was I,
> As I am now, so must Ye be,
> Prepare for Death and Follow Me
> —Church Creek tombstone inscription

Exploring cemeteries—reading the names, the dates, and the epitaphs of the dead—seems to cut across all other boundaries. On any weekend, it is not uncommon to see a number of the living wandering among the markers of the dead in burial grounds from Williamsburg to Havre de Grace. Some are genealogists and historians who make the study of the villages and cities of the dead a part of their vocation. Others come in

search of quiet, a connection to the past, or perhaps a place to meditate on the end that must come to us all.

One of the earliest regions of the United States settled by Europeans, the Chesapeake Bay area has a large number of cemeteries. Many of them date back to the early 1600s. Some are as vast and imposing as Arlington National Cemetery, and others are so modest as to have been lost almost as soon as they were dug. For instance, very few stones or memorials are to be found in the old slave graveyards that dot the rural Chesapeake. Under how many islands of overgrown briars and ancient trees, in how many lonely fields, lie the graves of families whose farms no longer exist?

If you expect to find in these pages the exact burial site of a Revolutionary War general whose name is remembered only by God and some grandes dames of the DAR, look elsewhere. This is not a history. This is a glance at a subject that sooner or later all of us will deal with, whether we want to or not. This is a potpourri of various and sundry morbid curiosities, oddities, and mortuary customs to be found in the regions surrounding Chesapeake Bay. This is, not incidentally, a *memento mori* for a culture, once unique in its regional character and shaped by its rural isolation, that has died in the latter half of the twentieth century. This culture—its language, customs, traditions—is a memory now, fast being sucked into the inexorable maw of homogenized suburbia.

Bit by bit, the past is swallowed up by the present. Where the white stones of tiny family cemeteries once dotted the vast open fields of rural Maryland, there are now developments of ostentatious houses crammed cheek by jowl on lots too small to contain them. The cemeteries have somehow conveniently disappeared. Stones turn up at flea markets in Delaware and Tennessee. No one seems to know how they got there, but they are avidly collected by a certain segment of the population.

But even before that, the forgotten dead were dealt with expediently; farmers, tired of plowing around old stones, would attach a chain to them and use the tractor to drag them aside. In the city, it was often easier to simply knock old stones on their sides and build over them than to move an old graveyard to the outskirts.

And after all, who really cared? The families of these dead folks had either died themselves or moved away or had simply lost interest in their forebears. Although legislation has been passed to protect old graveyards, the attitudes and beliefs that gave our ancestors such a rigid set of rituals associated with death and mourning, to say nothing of respect for the dead, cannot be legislated back into existence.

And I, for one, miss those rituals. Who, these days (save a president's widow making public appearances) would observe the old rule about wearing deepest, unrelieved black for a full year's mourning? Whatever happened to the custom of hanging a mourning wreath on the front door to mark one's household as a place of grief? Whatever happened to black bunting and the plumed hearse drawn by four sable horses? Does anyone serve corn pudding and baked ham at a wake anymore? Does anyone *have* a wake anymore?

I note with sadness that all the rituals and manners that were drilled into me as a child are no longer useful. I may own a black dress suitable for a funeral for each season, but I don't know anybody else my age who does. Recently, I saw someone at a funeral wearing lime green! A shocking decline in death standards!

I think these observances are due for a comeback. As my boomer generation edges closer and closer to the Final Exit, I want to see a revival of interest in death and mourning in this society.

Not only would these old-fashioned traditions and rituals be a great comfort to the bereaved, they could also restore some of the elegance and civility we have lost. It's hard to be armed and dangerous when you're balancing a funeral plate of boiled kale, corn pudding, turkey, baked ham, snowflake rolls, and Jell-O mold on your knee, after all.

Bring back the hatchments!

Acknowledgments

Many people were involved in the making of this book. As usual, all mistakes are mine.

"A gentleman and a scholar" are words so hackneyed that they have become an old-fashioned cliché. Yet, Dr. Kent Lancaster is that rare and wonderful person who is a true gentleman and a genuine scholar. His kindness, generosity, encouragement, and yes, charm, are deeply appreciated. Dear Kent, I hope you will accept this pastiche in the spirit in which it is offered. It would not exist at all without you.

My editor, Robert J. Brugger, displayed patience, tact, and the editorial skills for which he is so well known. Thank you, Bob. I hope it is all worth it.

Jeanne Pinault, my favorite copyeditor of all time, questioned, fact-checked, cajoled, cut, pasted, corrected, deleted, and proofread with her usual fine eye for fact, detail, and style. Thank you, once again, Jeanne.

Thanks to Hal Roth, a fellow untrained historian, who has been a supportive friend and generous fellow writer, for sharing from his collection of oral histories, for his vast store of regional knowledge, and for many Chinese lunches. No one knows better than Hal how to capture the voice of the Old Shore and the times "down below" before the Bridge. Thank you, Brother Roth.

I am also grateful to Arvel Johnson, who has shared his information and knowledge with me for this book. Arvel's memories and dedication to preserving old gravesites, especially African American burial places, were immensely helpful to me. Thank you, Arvel.

Last, and certainly not least, I am profoundly grateful to Turney McKnight. I hope, as I would with all my work, that this meets with his approval. Thank you, Turney, for getting the ball rolling and for keeping the faith.

In compiling my oral history stories, many of which I have heard since childhod, I used Michael Lesy's seminal work, *Wisconsin Death Trip*, as my model for blending many voices into one generic regional storyteller. So many people, both dead and alive, have contributed to these stories that it would be impossible to attribute them to a single person, save when noted in the text. Nonetheless, I would like to extend my thanks to friends who have been generous with their time and memories.

I am especially grateful to the late Jess Dean, who knew how to tell a story about the old days, and to my late father, L. E. Chappell, who could tell a few himself. I spent my childhood listening to those two old gunning and fishing buddies tell bigger and better stories.

The voices of Ed Dean, Dan and Edwina Murphy, Randolph Murphy, Lillian Mortimer, Chris Parks, Imogene Horton, and Tom Horton—good Eastern Shore natives and good friends all—echo through the oral histories here. Thank you, one and all. No writer ever had better friends or advisors.

The Chesapeake
Book of the Dead

In the Midst of Life,
We Are in Death

I was not allowed to go to my grandmother's funeral. I was five years old, and my mother, after some discussion with my father, decreed funerals unsuitable for little children. My brother, only three years older, got to go, however. That was clearly unfair and further proof that he had all the fun.

My grandmother had been lost to us for years, hidden behind a curtain of senility in a nursing home. Moreover, I had no idea of the significance of funerals.

Five-year-olds in the early fifties, the time of which I write, were sheltered from realities like death. It was the time of Eisenhower and silence, of angry words behind closed doors. My fears were immense enough, but vague—for instance, that people called the Red Chinese were going to take over our house, throw me out of my bedroom, and make me sleep on the floor and run errands for some child who didn't speak English.

When my grandmother died, I was placed in the care of a neighbor as the rest of my family went off to the funeral. To while away the time, I sat in the neighbor's yard, carefully fashioning a bouquet from the better flowers of her garden, inspired by the floral arrangements that had been arriving at our house. I thought I was kind of cute, I guess. The neighbor's opinion is not, fortunately, on record.

Later in the day my cousin Sue, two years older and permitted to attend the funeral, filled me in on the grisly details. By then the family had convened at my Aunt Walhalla's house, where we appropriated the whitewashed Adirondack chairs

overlooking a sunny yard. Inside, the adults were ignoring us as they prepared the funeral meal. Sue, a most worldly seven, gloried in her opportunities for storytelling and illuminated every detail. She knew that I wanted to hear every macabre bit of it, the funeral, the ceremony of the dead.

I have total recall on the scene as the two of us, prim little girls in our somberest clothes—she was even in white—surrounded by grass and sunshine, discussed the experience of funerals. She regaled me with interesting facts, hitherto undreamed of, about dead people, most of which are lost to my memory now but were surely choice. We both had a child's instinct for horror.

"And her face," Sue finished up, stroking the arm of her Adirondack seat, "was *as white as this chair.*"

Delicious shivers from both of us.

A few days after the funeral I dreamed about my grandmother, who by now was more vivid, in every sense of the word, than ever before in my half-decade of existence. She was standing in a sort of upright glass case—picture a very roomy gun cabinet done up for *Snow White*—with several other dead people, in the middle of a meadow. I was standing in front of this glass case with my mother and brother. When they looked away and while I watched, my dead grandmother would come alive with the ghoulish animation of the un-dead and attempt to unlatch the case—doubtless coming to get us.

I would cry out and my mother and brother would turn to see what alarmed me. But before they could see her, my grandmother would straighten up again, becoming once more a decently dead person, until they turned away. Then she would reach down . . . The scene played over and over, until I awoke in terror.

From a window in my bedroom, I could look out and see the hill in the cemetery where my grandparents were buried. I could see their solid granite tombstone in all weathers and know they were buried there. Maybe this fascination with tombstones started with them.

The dead were buried on our farm, too—people long forgotten by their own families, people whose lives were lived on the isolated Eastern Shore that existed before the Bridge. Their

Here lies the body and bones
of Old Walter C. Jones
By his not thinking
He lost Clean Drinking
And by his shallow pate
He lost his vast estate

Ca. 1700, found on what was
once the Rappahannock
estate called Clean
Drinking

resting places were scattered over the 1,800 acres on which my father bred Herefords, raised soybeans, and gunned for waterfowl. They rose as little oases of undergrowth honeysuckle and volunteer trees on the endless fields. The tops of crumbling obelisks and the white curve of old limestone monuments could just barely be seen above the rampant neglect. They seemed more forlorn than frightening.

Nevertheless, riding on the back of the old Ford tractor as my father harrowed the spring earth, I would study them from a safe distance, half afraid that the dead might have a taste for a mosquito-bitten, grubby little girl with corkscrew curls and too much imagination.

In those days, our house was always full of family—aunts and uncles and cousins who came down from Pennsylvania and sat at the round pine table in the kitchen, eating corn and crabcakes, sitting for endless adult hours on the screen porch, waiting for a cool breeze from the river. How could adults just sit for hours in the heat, talking in long slow voices and drinking iced tea, I used to wonder, when life was going on all around them?

We kids had better things to do. There were woods to explore, and the endless lure of the water, miles and miles of eroding, high-banked shoreline where all kinds of wonderful things might wash up. My brother found a cow skull once; I was very envious of such a prize.

And there was the cemetery across the cove. In the family folklore, the era before I was born always sounded a lot more interesting than mine. I knew, for instance, that the farm manager had once, before my time, kept beehives over there in the old cemetery. And I was certain that the ghosts that haunted our house came from there. It wasn't just the feeling of something not seen that permeated the house; it was the lonely call of the bobwhites and the whippoorwills across the cove, like lost souls eternally trying to find home again.

As we sat on the dock in the long summer evenings, we would look across the cove at the overgrown and neglected graveyard that had belonged to some previous generation of owners. It was a source of endless fascination to me, morbid little Wednesday Addams that I was; through the trees and the

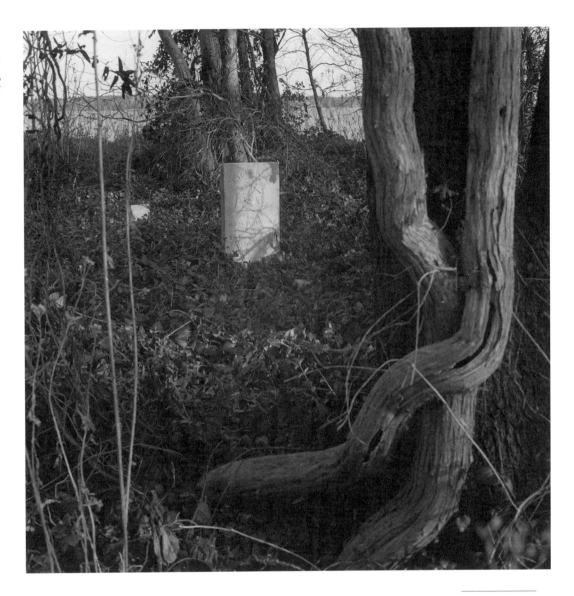

Haynie Family
graveyard,
Haynie Point,
Virginia

brambles, we could see the tops of the stones and the bits of wrought-iron fencing so popular with Victorian sentimentalists. Of course, we were forbidden to explore it.

"Stay out of there," my mother warned us. "It's full of snakes. Snakes just love to climb on top of those old tombstones and sun themselves."

She had explored it before we were born, when my father and she were first married, and had evidently seen a large black snake in there. Snakes were not high on her list of favorite things. When the occasional errant serpent found itself in our basement, her cries for my father to come and take it away were truly spectacular.

"We had some women who were related to those people come here once to look around in there," my father said. "Asked me why I didn't keep it cut back. It's not my property, it's the family's who buried their people there. We can't spare a man to go in there and try to whack all those vines out, we've got hay to get in. Besides, it's full of snakes."

My father was no big fan of our reptile friends either, although our barns were loaded with long, sinuous blacksnakes, grown fat on the mice who came to feast on the cattle feed.

Later, when my brother and I were old enough to be let out of sight, we spent quite a bit of time in there among those old tombstones. It was quiet, green, and haunted, although not a particularly old cemetery as old cemeteries go. The newest grave markers went back to the early 1900s, the oldest to the Civil War. I suppose there were only a dozen or so headstones inside the crumbling wrought-iron fence topped with mourning doves. Here and there, the descendents of tiger lilies poked their orange heads up out of the vines, reminding us that someone once tended this place, before the locust trees took root and shaded it from the relentless sunshine and rain.

There are probably a thousand other forgotten graveyards just like it scattered across the Eastern Shore, even today. The markers were white limestone, weather-beaten through the seasons, most of them askew or knocked down, mossily incised with the names and dates, the biblical verses, and the motifs of death and remembrance of another era. They were my first understanding of the past as a place I found interesting.

I was fascinated by the carved-out weeping willows, the hands whose index fingers pointed heavenward, the sheaves of wheat, the doves, and the bouquets of roses. I was learning that death, like life, has its fashions.

My cousins and I were particularly intrigued by one grave that had caved in, leaving a deep depression in the overgrowth. Obviously, the old wooden coffin had rotted away and collapsed, and the earth around it was slowly being eroded by the effects of water, but we were hopeful that it might contain a vampire or better. Well, you know what happened next.

It was like that Katherine Anne Porter story "The Grave." One of my cousins and I actually stole a shovel and made a half-hearted attempt to excavate it, being somewhere between a pair of neophyte archaeologists and preteen ghouls. Exactly what we expected to find, I am not quite sure. Suffice it to say that we gave up after a few attempts to dig through the thicket of vine roots the size of a man's arm. And my father gave us quite a bit of righteous hell about it when he found out, discouraging any further attempts at juvenile grave robbing.

Nonetheless, we continued to go back there to visit. Basically, we were interested in scaring ourselves witless, and since we weren't allowed to watch horror movies, this was the best way to do it. My brother, a particularly sinister storyteller, would terrify us in broad daylight by holding a flashlight under his chin and talking about the man-eating monsters who would reach up and grab us by the ankles, if we weren't careful, and drag us underground.

We dared each other to go over there after sundown, and plans were made to sneak out of the house after dark, but when the sun set behind the marshes and those whippoorwills started that long, mournful call, no one was particularly anxious to venture too far from the house.

"It's not the dead who can hurt you, it's the living," my Aunt Walhalla, a pragmatic and fearless woman, would say.

But we, the cousins, weren't too sure about that. We knew that things lurked out there in that graveyard, just waiting to get little kids. I'm still not utterly convinced that that's false. Graveyards, especially old, abandoned country graveyards, are best whistled past after dark.

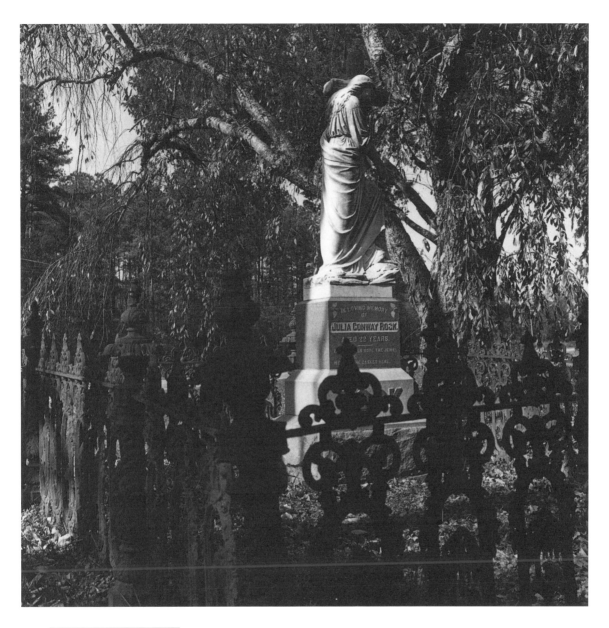

St. Mary's White Chapel,
Lancaster County,
Virginia

Barren Island,
Maryland

You never know.

Sometimes, as an adolescent, I would take a book and lie on the flat slabs of the old vaults, moonily falling in love with Mr. Rochester and Max de Winter and yearning for a life more glamorous and exciting than that of a surgeon's daughter in the middle of the twentieth century. The very age of the stones spoke to me of melancholy and yearning—surely the same emotions that the Romantics, those perennial adolescents, experienced. It was also a quiet place, far from the noisy twitters of family, where I could contentedly brood for hours, communing with the lost shades of the dead.

I loved the forgotten dead, and I later came to love the unforgotten, too—the ones with the showy monuments, the eternal flames, the statuary posed in despairing attitudes. The drama of death in high places compels my attention, of course. But obscure, everyday, mundane lives and deaths are literally under our feet in Chesapeake country; our lives are built on their bones. As you meet them here, greet them gently. *They are waiting for us.*

Now I sometimes think that I was the ghost who haunted that farmhouse and my childhood. A grownup ghost, haunted with memories.

Parting Shot

In the annals of bad marriages, John and Fidelia Custis of Arlington and Williamsburg have earned their spot in the top ten matches not made in heaven.

They were certainly married in a fever; one chronicler says that when they were courting, Custis paid a teacher at William and Mary five hundred pounds of tobacco to write a Cyrano-like letter to the lovely Fidelia, evidently a great belle in her day.

By the time the lovely flame died, the couple were communicating only through the servants, even if they were in the same room. For fourteen years, not a direct word was exchanged between them, and Fidelia divided the house into her half and his half. The problem may have been money: Custis was legendarily stingy, while his wife enjoyed nothing so much as spending.

When their son became engaged to Martha Dandridge (who later, as his relict, married George Washington) the feuding couple attempted a reconciliation by taking a carriage drive by the Chesapeake Bay. Frustrated by Fidelia's continued silence, Custis drove the vehicle, team and all, right into the water.

Madam Custis was finally prompted to break her fourteen-year silence. "Where are you going, sir?" she asked.

"To hell, Ma'am," replied her spouse.

"Drive on, then," she replied, without missing a beat.

In *Thrilling Legends of Virginia*, Robert F. Nelson calls their feud "the longest domestic strife in recorded Virginia history." Nelson reports that their contract of reconciliation is still on file. In this document, he says, the Custises agree to stop reviling each other, to provide each other with financial accountings, and to stop hiding each other's silver!

The rest of their married life appears to have been relatively tranquil. Fidelia died a few years later. John, however, had a long memory, as well as the last word in epitaphs. Although his Northampton County tombstone has been badly damaged by vandals, several accounts say it once read:

Under this marble tomb lies y^e Body
Of the Honorable John Custis E^sq.
of the City of Williamsburg and Parish of Bruton.
Formerly of Hungars Parish on the Eastern Shore of
Virginia and County of Northampton the
Place of his Nativity.
Aged 71 years and Yet Liv'd but Seven Years.
which was the space of time He kept
a Batcheler's house at Arlington
on the Eastern Shore of Virginia.

On the reverse it read:

Put on his tomb by his own positive orders.

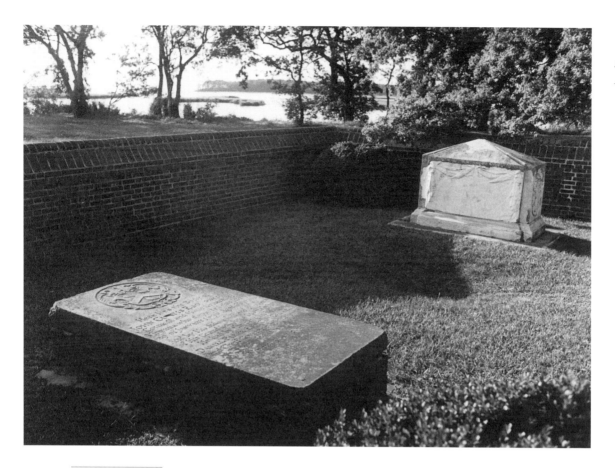

John Custis tomb,
Northampton County,
Virginia

She Came Back from the Grave

There was a preacher's wife who wasted away and died, and they buried her at Hole-in-the-Wall, where the church used to be. Some people say the name was Maynardier, I don't know anything about that, but all this happened about the time of the Revolution, or so they say. There must have been a lot of lawless folks about then, or this never would have happened.

But they buried her out to Hole-in-the-Wall, and when they buried her, she had a big ruby ring on her finger—the sort of ring everyone remarks on, which sounds pretty sporty for a preacher's wife, but maybe they did things different in those days.

Well, the very night they buried her, they went on home to have the funeral supper, and as soon as the preacher and the family and all of them were gone home, these two grave robbers come up from behind the tombstones where they'd been lyin' in wait.

See, they was sailors, coming across the peninsula, on their way from Baltimore to take ship in Lewes, and they weren't from around here, so they weren't up to any good, you can believe that.

Well, they stopped in the tavern that used to be down there to Hole-in-the-Wall, which I guess was a rough sort of place, and they heard about the preacher's wife who died and was buried with this great big ruby ring on her finger.

So what do you think that they did but go right on to the churchyard over there and dig that poor woman up?

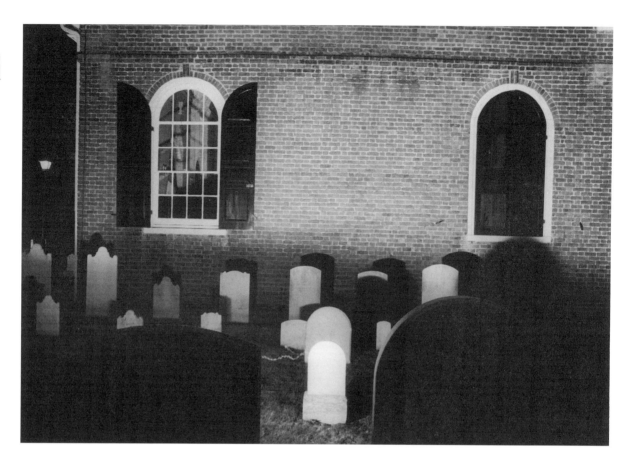

North East,
Maryland

Oh, they wanted that big ruby ring, I'm here to tell you!

So, they dug her on up and pried off the coffin lid, and there she lay, with that big old ring just a glittering on her finger in the moonlight! So they went to work and they jerked and pulled and tried to get that ruby off her hand, but that ring was on there tight, and it wouldn't come!

So what did them two but take a great big old knife and try to cut her finger off to get at that ring!

Don't you know, that woman sat bolt upright in her coffin and gave a scream that like to shake the glass out of the church windows?

Well, as it turns out, the woman wasn't really dead, she'd just fallen into a coma, the way people did in those days because the doctors weren't so good and couldn't tell she was just in a faint state. So when those two sailors cut her, the pain woke her up!

Well, you'd better believe them two boys took on out off. But that preacher's wife, she just gathered herself up and walked on home, about two, three miles down the road with her bloody finger wrapped in her cloak.

Well, they were sitting in the house mourning for her, her husband and her children and all the friends, and there come a knock at the door, and the husband opened it, and she fell right at his feet.

Now, don't you think that must have given him a scare? But that preacher's wife, she went on to live a good long while after that, ruby ring and all.

No one knows what happened to those bad sailors. They left there and for all I know, they're still running today!

You can hear this story all over the place, up in Pennsylvania and over to Virginia, and even in Cumberland, but it happened right here, at Hole-in-the-Wall, in Trappe, because my mother had it from her mother and so on down the line, until I'm telling it to you today! If you don't believe me, you go look for that old tombstone up there where you can see the brick walls of that old church. It's there!

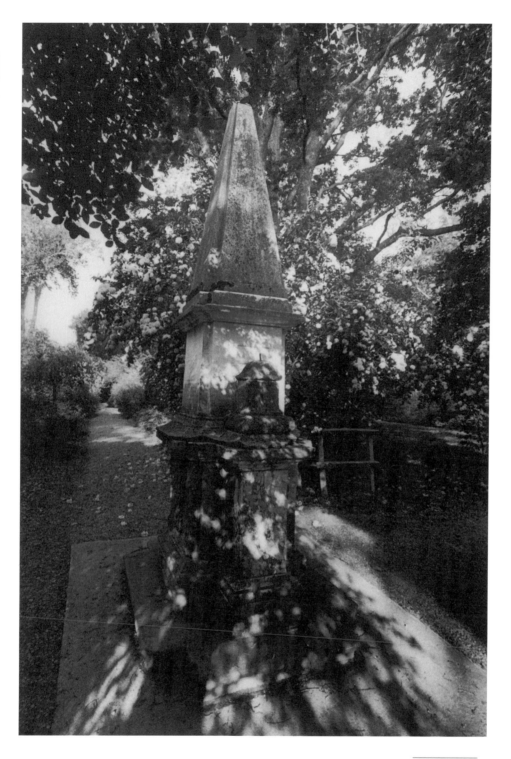

James River,
Virginia

Tales from Tidewater Virginia

The Antique Virgin

In Southern tradition, a tale of pining away for lost love attaches to any woman who dies unwed. Although several versions of this story exist, each one attached to a different lady in Chesapeake Country, perhaps the legend of Evelyn Byrd is the best known.

In the early eighteenth century, William Byrd was one of the richest and most powerful men of the planter aristocracy. Politically and socially well connected, he was a powerful figure in both Virginia and English politics and took great pride in his own sophistication and cultured attitude, so different from that of most colonials. To read portions of his diaries, one comes away with the feeling that the man was egocentric, ambitious, snobbish and cold, and an inveterate social climber. In short, he was a perfect man for power.

His home matched his position in the world. Of all the great houses of Tidewater Virginia, Westover is one of the grandest. This writer can remember being taken there as a child. More than thirty years later, memories of the restored red brick grandeur of Westover and the sad history of Evelyn Byrd still linger in my mind. It's the stuff of romance novels.

Evelyn, by all accounts, was as pretty and as intelligent a daughter as a powerful and ambitious father could wish. No doubt she was brought up in the mores of her time and caste,

taught from the earliest age that she was destined for an important marriage with a man who could cement her father's position in English society. Among the rich and powerful, marriages were made for convenience, not love. Emotional entanglements were considered rather downscale, and the idea of a man and woman married for love was considered quite déclassé. After marriage and the production of the traditional heir and the spare, the couple might look elsewhere for emotional gratification.

With all of this in mind, William Byrd took his ten-year-old daughter off to London to be educated and groomed for a future alliance. No doubt, Byrd believed that his Evelyn could look as high as she pleased when the time came. Perhaps he even hoped for a royal duke.

At first, all his ambitions seemed to be fulfilled. Evelyn was considered one of the great beauties of her day. Her position as a distinguished heiress did not hurt; men flocked to her, and if legend is true, she could have had her pick of any one of a number of peers.

Unfortunately, Evelyn did the unthinkable. She fell in love with a younger son.

In those days of entails and mortmain, younger sons, who inherited nothing and could expect little more than a few hundred pounds a year and a career in the military or the clergy, were simply not an option. Her choice, Lord Charles Mordaunt, was the grandson of a duke but, still, a younger son.

Byrd ranted and raved; Evelyn, who seems to have had some of the old man's strength of character, dug in her heels and insisted on her penniless beau or nothing. Byrd chose nothing, and Evelyn was packed back to Virginia in disgrace.

Father and daughter were at daggers drawn after that; Byrd sneeringly referred to his stubborn daughter as "the antique virgin."

In spite of many local suitors, Evelyn, it is said, remained true to her lost love, and slowly, in the best Southern Gothic tradition, pined away. She died at twenty-nine and is buried in the family graveyard at Westover. Her epitaph, undoubtedly if inscrutably composed by her father, reads:

Here in the sleep of peace reposes the body of Evelyn Byrd, daughter of the Hon^{be} William Byrd. The various and excellent endowments of nature, improved and perfected by an accomplished education, formed her for happiness of her friends . . . for the ornament of her country. Alas, Reader! We can detail nothing however valued, save for unrelenting death. Beauty, fortune or valued honor, so here have a proof! And be reminded by this Awful Tomb that every worldly comfort fleets away. Excepting only what arises from imitating the virtues of our friends and the contemplation of their happiness. To which, God was pleased to call This Lady on ye 13th of Nov^{br} 1737, in ye 29th year of her Age.

It is said that Evelyn's unhappy ghost still haunts the gardens at Westover.

Farewell our friends and parents dear
We are not dead but sleepeth here
Our debts are paid, Our graves you see
Prepare yourselves to follow we

Local lore has it that Jervis and Hannah Spencer, aged 13 and 16—who died in 1743 and are buried in the churchyard at Georgetown, Maryland, overlooking the Sassafras River—drowned in a boating accident.

Their stone, badly deteriorated and crudely repaired with cement, is decorated with a charming primitive angel blowing the last trump, signalling the dead to rise to join the living for the Last Judgment.

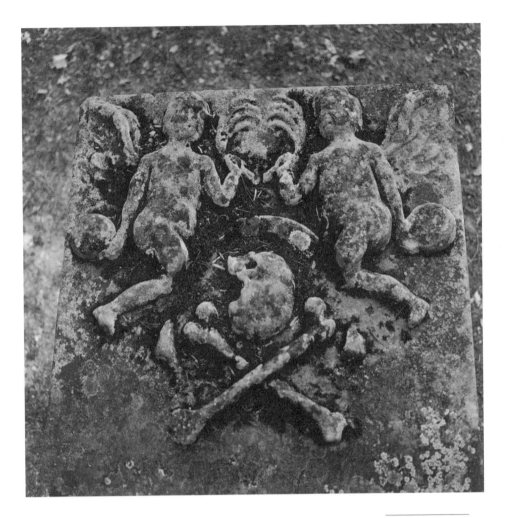

Skull and bones,
Aquia Creek,
Virginia

Another tale I remember hearing as a child, traveling with my father through Virginia, involved two old flat stones at Jamestown Island. Again, love is involved.

I listened, enthralled, as an elderly caretaker of that crumbling old church told me about Sarah Harrison and James Blair, who were married against their parents' wishes.

In spite of parental resistance, the union was a happy one, and when Sarah died in the mid-1700s, she was laid to rest in the old churchyard. Twenty-some years later, James followed and was duly buried beside her.

Several years after the cemetery had fallen into disuse, a poplar tree grew up between the two graves, pushing them apart. Supposedly, this was the fulfillment of the curse laid upon the couple by Sarah's parents, who had sworn that the couple they were unable to separate in life would be separated in death.

Old Borough Church

Unkind persons have called Virginia a mountain of arrogance between two valleys of humility, but Virginians' pride of ancestry accounts for the maintenance and restoration of many old burial sites that might otherwise have been lost.

Of particular interest is Old Borough Church, now surrounded by bustling downtown Norfolk. Although a house of worship was on this site as early as 1641, the present structure dates to 1739. It has survived both the bombardment of Norfolk during the Revolutionary War and use as a barracks during the War Between the States. The graveyard is notable for one of the earliest markers still in existence, a memorial to Dorothy Farrell, who died in 1673.

Equally notable is the unique skull-and-crossbones motif found on many of the older headstones. All appear to be the work of the same carver.

A legend surrounds the unusual slab marker of Mrs. M.A.E. Duncan and her two infant children, who died on May 12, 1825. The stone carries the image of Death as an archer whose arrows strike down the living. This is an uncommon motif, perhaps because of the difficulty involved in carving the image in stone.

According to local lore, Mrs. Duncan's husband, who was on a long sea voyage, had a vision of the death of his family. He arrived home to discover that his wife and children had perished in a fire at about the same time that his vision occurred.

The epitaph, obviously chosen by a grieving husband and father, reads,

> Insatiate archer, could not one suffice?
> Thy shaft flew there thrice, and thrice my peace was slain.

Customary Woe

Colonial, Federal, Victorian

When Europeans first came to the New World, they had little time or money to indulge in the full-blown mourning customs of Europe. Generally, a black dress or cloak would do for a woman, while men contented themselves with black armbands or sashes to express their bereavement. "At least such was the customary woe," noted diarist Samuel Sewall of a funeral he attended in 1688.

Death was a fact of life, and treated as such. In a way that is not easy for modern minds to fully comprehend, dying was a spiritual and moral exercise, something to be prepared for from birth. An afterlife in heaven was a goal earnestly sought.

But our ancestors lived with death as a fully integrated part of daily life. The fortunate died at home among their multigenerational families; the death of a child caused less concern than the birth of one, so likely to cost the life of the mother. Life was cheap, but also as "nasty, brutish and short" as Hobbes ever pictured it. For those who survived childhood, death was the order of the day in an age of war, pervasive capital punishment, religious strife, epidemics, primitive medicine, ignorance, and filth.

Records and histories indicate that the earliest colonists buried their dead in secret, in unmarked graves, so that neither the Indians nor the marauding Dutch and Spanish would know how depleted their numbers had become. And depleted they were: starvation and disease killed off more than a third of the Jamestown colonists in the first winter.

By the 1700s, however, the customs that abided at home in Europe were appearing in the Chesapeake Bay region. Grave markers were thrown up, and the dead were buried with ceremony and public religious rites.

The dead were laid out on shrouds or winding sheets—long lengths of undyed material, usually finely woven wool or linen—which were tied at head and feet with narrow ribbons of the same material. The jaws of the deceased were often bound with another strip of cloth, and coins were laid on the eyelids to weight them down. The fashion for shrouds persisted well into the eighteenth century, although it was not unknown for people to be laid out in their best clothing.

Only the rich could afford coffins, and then only the familiar hexagonal box of plain wood. The very rich or very important, however, might be able to afford lead coffins, which were sealed tight with lead solder. In 1995 archeologists digging at the site of St. Mary's City exhumed members of the Calvert family in lead coffins that had been sealed in the 1650s.

The bereaved family would send out black-bordered cards announcing the death and inviting mourners to attend the procession to the burial site. Examples that survive from the seventeenth and eighteenth centuries show motifs like death's-heads, mourning cherubs, skeletons with scythes, and up-turned hourglasses.

In some locations, mourners could expect to receive a pair of black gloves as a token of attendance. Elisabeth McClellan in her *History of American Costume* notes that in addition to black gloves, family members and close friends were also given mourning rings engraved with the name and death date of the deceased.

In communities of German origin, one could expect to receive "toddycakes," small, cookie-like pastries made from rye flour, honey, and spices prepared in honor of the deceased and, of course, *der Tod,* who had borne him or her away.

A rather grotesque *memento mori* that can still be found in antique shops is mourning jewelry and wreaths made from the hair of the late lamented, or sometimes several of the late lamented. Intricately braided bracelets, rings, and necklaces made from human hair, with single strands woven into com-

Leaves have their time to fall
And flowers wither
At the north wind's breath
Thou hast all seasons for thine,
Oh, Death!

—Cecil County,
Maryland

plex patterns and fixed with ribbon and gold or silver findings, were distributed among relatives and close friends. Wreaths of human hair, each strand wrapped around tiny wires and shaped by patient, dedicated fingers into the likeness of flowers, leaves, and birds, were sometimes displayed in round glass bezels. If an artist had been summoned to take a likeness of the dead, as sometimes happened, the head and shoulders might appear on a black-bordered mourning miniature, with a lock of hair braided and displayed on the reverse of the portrait.

Even before Victoria, death was a highly romanticized and religious subject. The education of women was limited, even in families that could afford to send their daughters off to school. If a young woman emerged into adult life able to read and write and do some basic mathematics, she was fortunate. Far more often, she was considered "accomplished" if she could play a musical instrument, sing a little, and do fine needlework and watercolors.

It is the combination of the Romantic age, needlework, and watercolor that give us that peculiar subgenre of folk art known as mourning pictures. Generally a project for schoolgirls, and sometimes schoolboys, these little pictures often follow the same allegorical motif: a *pleurant,* or mourning figure, leaning, helpless with grief, against a cenotaph that bears the name or names of the late departed. In the background, the landscape is often adorned with weeping willows, running rivers, distant hills, and other symbols of the Eternal Landscape. The idea was to create a *memento mori* for a departed relative or friend, which may seem ghoulish today but fitted in perfectly with the sensibilities of the era that created Shelley, Keats, Goethe, and the idea of death as a romantic dream state.

If no recently departed were available, the inscription on the cenotaph was left blank, to be filled in when the need arose. And the need arose frequently. Women died with terrifying frequency in childbirth in those days of puerperal fever, and infant mortality was so common as to lead to the practice of bestowing successive infants with the same Christian name until one survived into adulthood. Since women frequently were pregnant almost every year over their entire reproductive lives, it is not uncommon to find tiny tombstones lined up one after

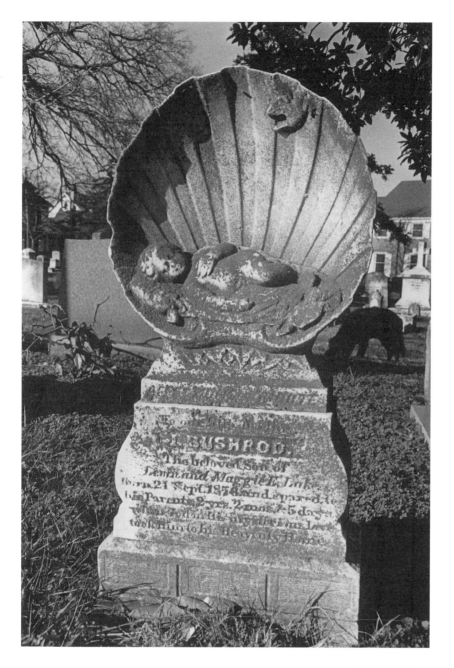

Cambridge,
Maryland

Lower Eastern
Shore, Virginia

Kinsale, Virginia,
near Great House

the other in old cemeteries. One may also see several mothers lined up alongside the same father—widowers were quick to re-marry.

The story is told about the great Methodist preacher Joshua Thomas, "the Parson of the Islands," who proposed to a young lady only a few months after the death of his first wife.

"Is this not very sudden, Reverend Thomas?" the young lady exclaimed.

"But I've had my eye on you for quite a while," Thomas is said to have replied.

Mark Twain created Emmeline Grangerford as a satirical take on death-obsessed young women in *Huckleberry Finn*, which takes place on the Mississippi but probably could have been set with equal accuracy on Chesapeake Bay. Huck's description of a mourning picture is as good as any: "They was different from any pictures I ever see before; blacker, mostly, than is common. One was a woman in a slim black dress . . . and she was leaning pensive on a tombstone on her right elbow, under a weeping willow, and her other hand hanging down her side holding a white handkerchief and a reticule, and underneath it the pic-ture said 'Shall I never see thee more, alas?'"

Emmeline has "passed over" herself by the time Huck Finn and the reader meet her, but Twain made her a good daughter of the Romantic Age, to be poked with a sharp pen. Not content with the mourning pictures that Huck describes, Emmeline also wrote execrable mourning poetry and obituaries. Still,

> When did young Stephen sicken
> And when did young Stephen die?
> And did the sad hearts thicken?
> And did the mourners cry?

is no better and no worse than much of the contemporary obit-uary and elegiac literature written by perfectly sincere people along the Mississippi and by the Bay.

I am a Tarheel born
I am a Tarheel dead.

—Kate Faison (d. 1924), Old Shrewsbury Church, near Kennedyville, Maryland

Batwings

One summer day, a friend and I went in search of an old tombstone—not just any tombstone, mind you, but a genuine legend of local fable and folklore known as the Batwing Stone.

Oh, sure, they're out there. I'll tell you where.

There was supposed to be a town out there on North Dover Road, but it dried up and blew away long before the Revolutionary War. They used to call it the lost city of Dover. Lost! Huh! It lost out to Easton, that's what got it lost. You can still see the old brick foundations, the folks that fly over there in those small planes talk about that.

Anyway, sure, there are these three tombstones out there at North Dover, at the edge of the farm, in a grove of black locust trees. They're bright red, you never saw anything like it. It's the middle one everyone knows about, the one with the skull on it, with the laurel wreath and batwings. It's a little boy's grave. His name was Samuel. They say that he died from a rabid bat's bite. That's why they used those batwings on the stone.

We used to pass that stone hunting all the time out there; that's why I know the story. My daddy told it to me, and he heard it from his daddy before him, so it must be true.

But you go out and look at that stone with the batwings. And you'll think about that poor little rabid boy under there all these two hundred years and more, and it sort of makes youwant to cry.

You can't read the other two stones that well anymore. But I heard tell one was his mama and the other a brother, and they all died from bat rabies.

They say in those days, they brought those stones down as ballast in ships from New York, with the pictures all carved out and ready to be set up. Then those old country peddlers would add 'em to their stock, and take 'em around to all the places where they didn't have any natural stone, like. Then someone local, a brickmason or whatever, would add the name and the dates and the fancy epitaphs.

Of course, only rich people—little Samuel must have come from well-off stock—could have those fancy stones. Poor people had wood or did without. This ground must be thick with poor people who did without. Didn't help Samuel much not to be one of them.

But it is a pretty stone, as these things go. When the sun rises on it, it's the color of blood.

After getting directions from a local farmer, we climbed a fence and hiked across a hot field along a lonely stand of pines. About a half mile down the path, we found it, just where local legend said it would be.

Nestled in a stand of black walnuts, the Batwing Stone rose in the heat from the tangled undergrowth, facing east toward resurrection.

The red sandstone glowed in the setting sunlight, and the wonderful death's-head, crowned by laurel leaves and supported by grimly spread batwings, stared out at us from reflective, hollow eyes. The rictus mocked us as we both stood suddenly silent and awed. Even though it was a hot summer afternoon, it was as if a cold, tingling breeze had passed over us. Chiseled in high relief, it had withstood time and weather remarkably well. Marking the grave of Samuel Harrison, who died at the age of eleven, in 1754, it has stood for two hundred and fifty years and may well stand for two hundred and fifty more, a bleak reminder of a short life.

The stone and its two companions, also deeply carved red sandstone, are said by scholars of such things to be unique examples of tombstone carving. Nowhere else, at least in Chesapeake country, is there such a stone.

By his monument, little Samuel Harrison attained a fame his short life would never have accorded him otherwise. Dying

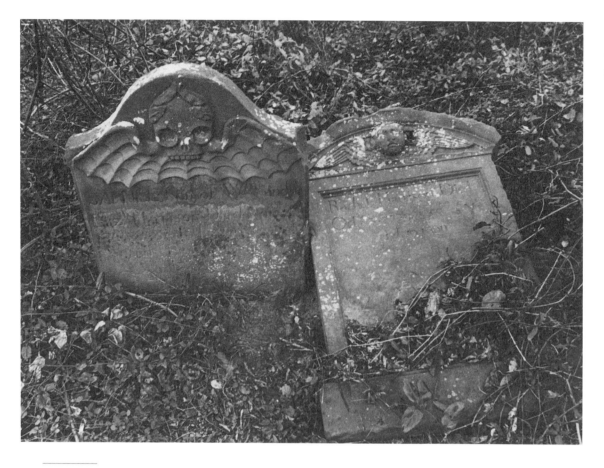

Batwings,
Talbot County,
Maryland

young of incurable disease was not, in that century, uncommon. My friend and I can bear witness: The way the Batwing Stone conveys the cruelty of a painful, unpredictable, and premature death across the years distinguishes it, not just as a tombstone, but as a work of art.

Stop Gentle Friend and view this Sacred Spot
Consider well, his fate will be thy lot
Cut off in manhood's prime, a stranger here
Oh, drop the tribute of a brother's tear
Be this our prayer, a mark of Odd Fellow's love:
Jesus admit him to thy Lodge above

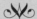

—Samuel S. Birnham (d. 1812, aged 21),
Sater Church, Chestnut Ridge,
Baltimore

Harriet Tubman Is Buried Away

I'm sitting in a pocket park on Race Street in Cambridge, Maryland, talking to two nineteen-year-olds about Harriet Tubman. Nineteen-year-olds, young men, I had previously thought, cared nothing, nothing at all, about history, let alone the details of Harriet Tubman's remarkable life and career. Turns out that LeVerne Simmons and Brian Hastings know more about this lady than I do, and I had assumed that I knew quite a bit. LeVerne and Brian are volunteer guides for the Harriet Tubman Museum up the street. It's their job to chaperone the Harriet Tubman tours for the seekers who come here in search of history. The history books can tell you all the facts, but we three are talking about Harriet as if we all know her. And in a way, maybe we do. This is the stuff of magical realism, the way threads of past and present are loosely woven into the daily fabric of marshy old Dorchester County. Harriet Tubman's spirit might be sitting on this bench with us; no one would be too startled.

"And," Brian is saying, "did you know that when they were going to sell her sister, at Spring Valley, over beside the courthouse, Harriet came down on a ship and rescued her?"

No, I didn't know that, but I am learning, sitting here in the late afternoon sunlight. Long after the rich white guys, the legislators and the generals, have crumbled into obscure footnotes, Harriet Tubman, an African American woman, born a slave, is remembered and celebrated here. Harriet Tubman was the ultimate escape artist.

By trade, I am an escape artist, too, but of a different breed. I'm a writer. Creating alternate worlds into which you and I can flee to shed the shackles of ugly reality is a big part of my job. But there are gray days when the words pile up in a heap. Plot lines, so promising in the outline, lead nowhere on the page. Inspiration dead-ends without warning. Characters strike for better dialogue. Then, the escape artist needs an escape. Time for a road trip. Head out of town, go to the marsh. This escape is about freedom of the mind, just as much as Harriet Tubman's escapes were about freedom of the body. To go down to the marshes visiting Harriet's haunts is to free up my mind.

People have disappeared into these wooded swamps and vast wet savannahs, never to be seen again. Strange things happen here. The places where Harriet hid, more than a century and a half ago, have not changed all that much. Coming into the marshes, I can feel Harriet listening for the baying of the bloodhounds over the beating of her heart, moving by night toward freedom, taking the North Star as her guide. At certain times of the year, the North Star shines like a jewel in the night sky over the open fens.

I follow twisting roads over narrow, rattling bridges, around the marshy shores of shallow, dark rivers and thin guts that loop back upon themselves. Even the place-names have a wild poetry: The Blackwater and Little Blackwater, the Transquaking and the Chicamacomico Rivers drain this vast wetland into the Bay. Fishing Bay. Little Duck Island. Two Potato Marsh. Egypt Road. Savannah Lake. Backgarden Creek. De Coursey Bridge. Greenbriar Swamp. Crapo. Maple Dam. Hip Roof Road. Some of these places have fallen into the inexorable marsh, leaving only their names behind.

Ancient revenants live out here. In a territory of stark and beautiful isolation, landmarks are few: an abandoned church or a distant farmhouse, a cripple of high ground where wind rustles through a few straggling loblollies. Humans are intruders here; it's the mosquitoes, the hawks, and the muskrats who own this place. Endless blue sky, endless yellow grass; a drowned land.

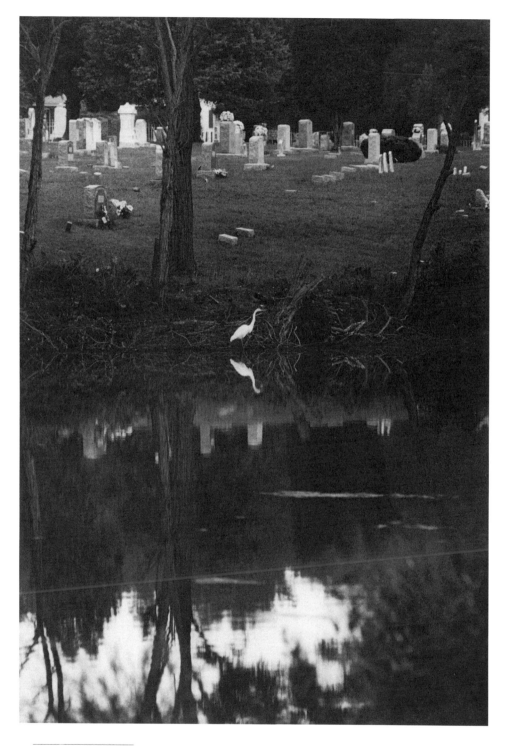

Roseland Cemetery,
Reedville, Virginia

Hope Union Church Cemetery,
near Lillian, Virginia. A former
slave, Hannah Crocket lived
to the age of 115 years.

It is desolate out here but never lifeless. I turn a corner on the causeway and come upon an enormous bald eagle, wings as wide as a man's arm span, spread and shimmering in the pale sunlight, cold yellow eyes glaring at me as it tears the guts from a nutria with its huge curved beak.

At the general store and café on Taylor's Island, I eat a crab-cake and stare moodily out across the Little Choptank toward my homeplace, listening to the watermen at the bar. Trappers and hunters and forgotten ghosts talk about the weather and wetlands; I'm just an invisible visitor from another planet, out on a day pass.

When I slowly gather myself up to return, Harriet's ghost is a hitchhiker, riding along in the passenger seat, laughing at my foolishness. "This is where I get out," she says, disappearing just as I cross the Choptank River Bridge, heading back to my other reality.

In 1994, at a service held at St. Philip's Episcopal Church, Great Choptank Parish, Cambridge, Maryland, Harriet Ross Tubman was nominated to the Episcopal Church's Calendar of Saints.

She is buried in Auburn, New York. Her tombstone says, "Well done, Thou Good and Faithful Servant."

A Lonely Place to Lie

Pooles Island lies in sight of Baltimore Gas and Electric's stacks at Middle River. Once a farm occupied this island in the Upper Chesapeake. They say the place was famous for its peach orchards. The farm and the peaches are both long gone, and most people don't care to explore the overgrown, forbidding interior of the island, full of thorny greenbriar and black locust trees.

Now the U.S. Army owns it, and they don't encourage visitors, even those who come by Grady White from Middle River to see a double tombstone and read a sad story.

Coming around a bend in the island, I see a double stone half buried in the sand, concealed in a stand of phragmites and marsh grass, half fenced in by heavy iron chain. Volunteer peach trees, scraggly descendents of those famous orchards, shade the old grave. The epitaph tells the sadly familiar story of life and death on the Bay.

In Memory of
Captain Elijah J. Williams
aged 24 years
who was lost in a snowstorm
February 24, 1855
His body was found June 12th, 1855
And interred in this place
Also to the memory of his brother
Captain James Williams
Aged 26
Lost with him at the same time
His body has never been found

No friend's hand did close their eyes
They saw no tear, they heard no sigh
And in the waves they lost their breath
And they endured a watery death

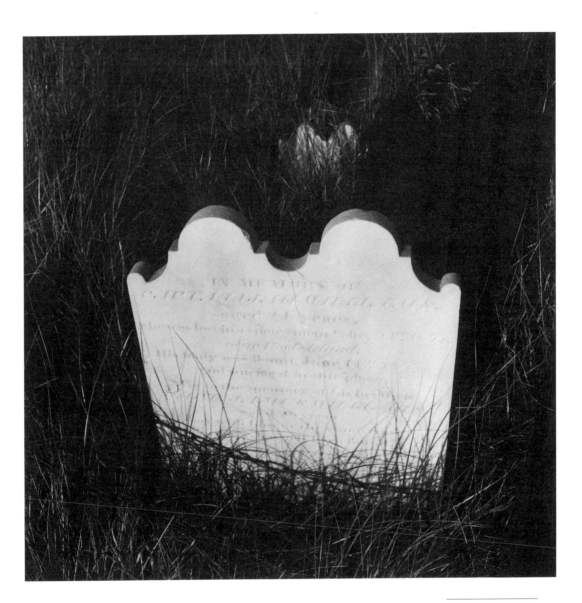

Elijah J. Williams
grave, Pooles Island,
Maryland

The Last Word

Mourning and Dying
in Style

Fashion in Mourning

Queen Victoria's endless, very public display of grief for Prince Albert, as well as her decided tastes in necro-chic (perhaps influenced by a childhood in the Romantic Era) set the fashion, first for England and later for America. Ascendency went to the sentimental, visible trappings of grief.

The American Civil War certainly gave impetus to this obsession, at least in the United States. Death, which had been romanticized by the poets, took on a sort of fatal glamor as the bereaved widows of Union and Confederate dead displayed their status in ever more elaborate mourning dress and bereavement rituals. Widow's weeds, of deepest most dull black, were *the* fashion.

Just as the groom had become a secondary, if concededly essential, accessory to the elaborate wedding, so the deceased became an object of lesser public interest than the bereaved. Moreover, since theirs, like ours, was a fin-de-siècle era of conspicuous consumption, the whole grieving process was marked by excesses.

To announce to the world at large that a death had occurred in a well-to-do household, the hatchment, a black-draped panel bearing the coat of arms or another insignia of the deceased, was placed above the main door of the house. Black bunting sometimes was hung from the street windows, or, in more modest homes, a flower wreath, tied with black ribbon, was sus-

pended from the front door to announce that this was a house of mourning.

In affluent urban neighborhoods, the street outside was covered with straw to muffle the noise of horses' hooves and traffic.

Inside the house, the deceased was generally laid out in the front, best parlor, where the family "sat up with the dead" and received condolence calls. If the weather was warm, the corpse was often packed in ice and the face frequently sponged with a wet rag. In those days when embalming was nonexistent or primitive, waiting for the arrival of faraway relatives could be dicey.

With the arrival of photography, it became fashionable to have a last picture taken of the deceased in the coffin, sometimes with the mourners posed about.

When the deceased was finally conveyed to the burial site, it was often in a hearse hired from a livery stable or the undertaker for the purpose. Drawn by jet-black horses sporting black plumes, the hearse, once a simple bier, had also become a lavish display, often richly carved.

The shroud was replaced with the laying-out outfit. For men it was generally a good suit, for women either the best dress or a nightgown and peignoir set. It was not unusual for women to save a fancy dress or gown from the bridal trousseau, carefully stored away in lavender and tissue, "to be buried in." Small children were laid out in their christening gowns.

To truly mourn in style, the widow had first to drape herself in deepest black for a year following the funeral. Only the dullest, most matte of materials were used for widow's weeds; anything shiny or reflective was considered, well, tacky. She was not expected to go to public events like concerts, parties or weddings, and if she did go out, she dressed from head to toe in full black and topped off the costume with a veil of thickest, blackest net, which was pinned to her hat in such a way that her face was invisible.

At the end of six months, the veil could be exchanged for one of a lighter but somewhat opaque material. She might adorn herself with some jet-beaded jewelry, and she might entertain a few friends quietly at home and go to church. At the end of a year, she might exchange the veil for yet a lighter number, and

move into gray clothing; then, at eighteen months, to mauve and white clothing and a white veil. Now, she could attend the quieter sorts of social events and the most uplifting and serious-minded concerts and lectures. At the end of two years, she could resume wearing colors and jewelry.

For men, the rule was a black suit for a year, then gray, and finally colors at the end of eighteen months. Presumably, widowers were considered less prone to grief than widows, and considering the alacrity with which they remarried upon the deaths of their wives, it is not surprising that they topped off their mourning period with only a black armband.

Degrees of mourning dress were more rigidly observed than medieval sumptuary laws. So much time, so much black for a spouse, a parent, or a child. So much time for a sibling or an aunt or uncle or cousin. One source even marvels that an etiquette book of the 1880s decreed the exact mourning for a distant relation who has left one an inheritance!

Of course, the more money and leisure time available, the more prolonged and ostentatious the mourning could be. Since it is mostly the garments of the rich that have come down to us, we know much less about how the more financially challenged dealt with mourning displays.

But a gentleman of my acquaintance, now well into his eighties, likes to recall that his mother was careful to observe the exact degrees of visible mourning in her isolated Chesapeake Bay community. For six months after a death, he recalled, she would wear a thick black veil to church; for the next month, a gray veil; and for a month after that, a white veil served to alert the town to her degree of mourning.

As a child, I was informed by my aunts that the very least I was expected to do to show my grief for the death of my grandmother was to wear a black hat to church. I had black felt for winter and black straw for summer, and this was how I passed the Sundays of my sixth year.

Between the turns of the eighteenth and nineteenth centuries, children were expected to wear at least six months of mourning for parents, grandparents, and siblings, but after World War I, this custom pretty much fell away. The somber little black dress or suit for the funeral would do. Indeed, most

Nothing became [his] life
so much
As his leaving of it

—Gravemarker (ca. 1835, name and dates illegible) found near Onley, Virginia

Nothing in his life became him like the leaving it

Macbeth I, iii, 7

people now consider it inappropriate to allow young children to attend funerals at all.

Today, the custom of wearing black at funerals is all but forgotten, and one is appropriately attired in anything of a reasonably sober nature. Unkind souls have suggested that the enormous black sunglasses worn by the late Jacqueline Kennedy Onassis are the modern equivalent of widow's weeds.

Times change, and perhaps less funeral drama is better than more—although a recent funeral for two young men, murdered during an alleged drug deal gone bad, where newspaper photographs showed the pallbearers in Metallica T-shirts and jeans and the grieving parents in shorts, seemed a bit too casual to me.

Dying as Performance Art

In eighteenth- and nineteenth-century Chesapeake country, dying was a socially acceptable activity; indeed it could be what today is considered performance art. Dr. Kent Lancaster, formerly of Goucher College, has studied the expectations of survivors at the Federalist deathbed. Men were expected to slip off the mortal coil in a manly way, he says, with little fuss and no bother. A speaking look and a hearty handclasp, perhaps a brief exhortation, were all that was required of a man. As survivors, they were also expected to handle themselves with little more than a flexing jaw muscle to betray their deep emotions.

Women, on the other hand, had already "domesticated and feminized" a parlor fascination with death. A woman studied hard for her deathbed performance and knew what was expected of her. Ideally, one should die a lingering death, in order to be attended at the last by family and friends. And attend they did; a deathbed was an experience not to be missed, for it was considered to be as morally edifying for the survivors as the dying. "Baltimoreans attended deathbeds as easily and naturally as they did weddings, except that they continued to hope that the former might be more instructive," reports Lancaster.

Apparently, the great hope was that the dying person could reveal some of the mysteries that lay beyond the grave, but the attraction must have been, as well, the great *drama* of death. And the well-bred woman was prepared to play the lead role, in

Deal Island,
Maryland

Tangier Island, Virginia
(original burial on
Watt's Island)

four parts. First, the dying woman must be the Beloved, "expected to show only the most positive and pleasant personal traits . . . as something of a trial run for the heavenly personality" and the way the nearly dead should be recalled in the future. As the Healer, she was expected to "bring them all together, soothing any troubled relations among them." Third, as the Resigned, only "complete acceptance and welcoming joy at the approach of death" was expected behavior, although "success often required considerable interpretation." The fourth role, that of Instructor, Dr. Lancaster says, "was seldom achieved" but much hoped for. As Instructor, the dying person was expected to reveal a vision of the afterlife.

Attempting an "edifying deathbed"—highly desirable, however infrequently achieved—must have been distracting, at the very least, for the dying. Still, one must assume from the high attendance at deathbeds that the farewell performance was always well received by the real-life Emmelines of the day.

Wye Mills Church,
Maryland

Congressional Cemetery

Resting among the late, and mostly forgotten, congressmen and socialites in the ostentatious memorials of down-at-the-heel Congressional Cemetery in Southeast D.C. are celebrities like Civil War photographer Mathew Brady, March King John Philip Sousa, ominous FBI Czar–putative drag queen J. Edgar Hoover, and the Massachusetts signer of the Declaration of Independence and fifth vice president, Elbridge Gerry, who is best remembered for lending his name to the term "gerrymandering."

Anne Royall (1769–1854), prototypical muckraking journalist, pioneer feminist, and patron saint of women journalists, is buried here, too. In a remarkable and lively career that spanned four decades, Mrs. Royall's periodicals, *Paul Pry* and *The Huntress,* poked at the high and mighty with the sharp end of her pen, just as the lady herself was known to poke at the real men with the tip of her umbrella. Legend has it that in order to interview President John Quincy Adams, she followed him to his favorite swimming hole in the Potomac and sat on his clothes, piled on the riverbank, while she got her story. Her journalism so irritated Francis Scott Key, Jackson's secretary of war John Eaton, and *Washington Intelligencer* publisher Joseph Gales that they actually had her tried on the archaic charges of "being a common scold"!

They may have won the suit, but the prescribed punishment, to be dipped on a ducking stool, was too much for an outraged public as well as the judge in the case. She was fined $10 in-

Bruton Parish Church,
Williamsburg,
Virginia

stead, and two of her fellow reporters paid the fine as a gesture of their regard for the First Amendment.

In the end, she and Adams formed a grudging friendship. His eulogy of her said, in part:

> She was a virago errant in enchanted armor, redeeming herself from the cramps of poverty by the notoriety of her eccentricities, the insane fearlessness of her attacks on public characters. She was the terror of politicians, and especially of congressmen.

Also buried at Congressional is Choctaw chief and notable military tactician Pushmataha (d. 1824), who, against overwhelming odds, successfully negotiated a number of land treaties with the whites on behalf of his tribe.

After becoming chief in 1805, Pushmataha allied his people with U.S. military interests, believing in peaceable solutions to land and cultural problems. In the War of 1812, he led his warriors into the Battle of New Orleans with Andrew Jackson and thereafter successfully negotiated treaties with Jackson that ensured the Choctaw Nation a large section of what is now Arkansas and Oklahoma in exchange for their eastern territories in Mississippi and Alabama.

President Monroe, flush with what the United States claimed as a victory in the War of 1812, demanded that Pushmataha return to the District to renegotiate. When the Native American reluctantly did so, he either caught a chill from the bitter winter weather, or, according to contemporary Native Americans, was poisoned. In either case, he is buried at Congressional, far from his home and the Choctaw people he tried so desperately to protect.

Murdered by Cyrus Stack

Up to Brookview, in north Dorchester County, by the bridge, there's this little cemetery, and in this cemetery, there's a tombstone for a Benjamin Rhodes, who was a big man in these parts in the old days. They named Rhodesdale, the next town over, after his brother Richard; they were both big men in these parts.

Around about the time of the Civil War, Benjamin and his wife Mary owned the store in Brookview, and he was postmaster, see? In a small town, that would make him a big man.

Anyway, fella name of Cyrus Stack murdered him. It says so right on his tombstone. "Benjamin Rhodes. Murdered By Cyrus Stack, December 20, 1869." Four days before Christmas!

It was right after the Civil War, and passions ran high. They say Stack ran off to South America and was never seen again.

Anyway, you can see that tombstone right there in that little cemetery in Brookville, right by the bridge. Murdered by Cyrus Stack. Isn't that something?

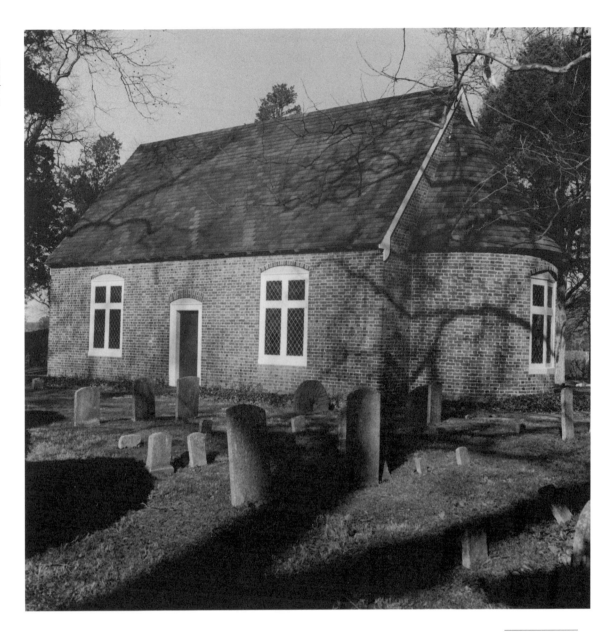

Church Creek,
Maryland

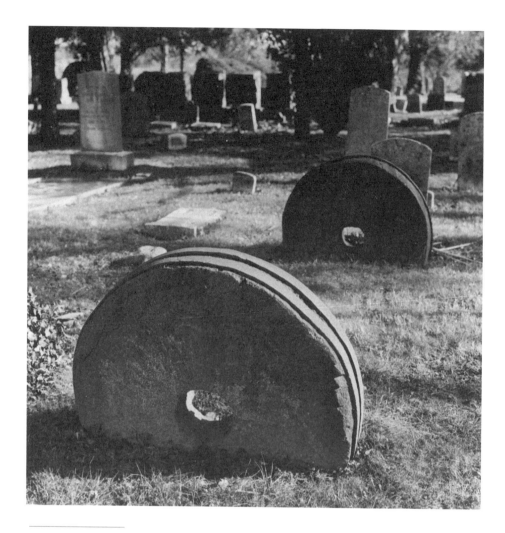

The miller's grave,
Church Creek,
Maryland

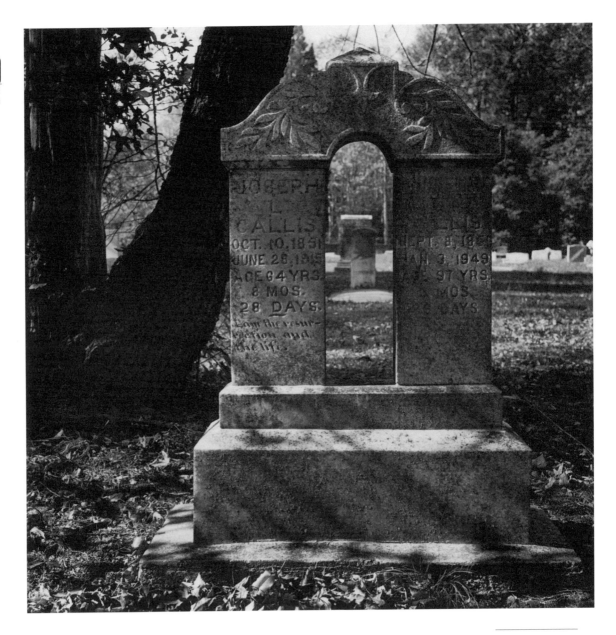

Gwynn's Island,
Virginia

Death and the Doctor

Notes from a
Nineteenth-Century
Diary

From the Daily Record for 1877–1878 of Dr. George S. Dare, M.D., physician in Rising Sun, now buried among many of his patients in the Rising Sun Cemetery (from the collection of Peter L. Whitesell, M.D.)

1877–

Mrs. Ella Meadley, Rising Sun, age 40. Widow. Died Sept 9th, diagnosis, phistitis pulmonitis
 This case came under my care about a week before death

Mrs. Barber, Paper Mill, aged about 60. Died Oct. 6. diagnosis, Abscess of the brain
 Mrs. Barber lived 36 hours after I saw her; was having liver spasms and when I first saw her was unconscious.

Mrs. Mary Breston, Colora, aged 65, widow, died Oct. 14. Diagnosis glandular disease.

Geo. W. Gaines, Rising Sun, aged 38, married. Died Dec. 19. Diagnosis tuberculosis.
 had been sick four years

Allen McKinney, Above Rising Sun. aged 40, single.
Died December 25. Diagnosis: Typhoid fever.
*Has been sick since November 18th. Almost all the time delirious
and sick 38 days.*

1878–

Mrs. John Wilson, Harrisville. Aged 73. Married. Diagnosis.
Apoplexy
 She lived 41 hours.

William Reeves, Rising Sun. Age 3. Died August 7. Diagnosis:
Cholera infantum

Ellen Barrett, Colora. Married; aged 60. Died August 8. Diagnosis Paralysis.

Kelly Pearson, Principio. Aged 60, Married. Died August 30.
Diagnosis: Bright's Disease.
 I consulted with Dr. Brown

Harvey Reynolds. Reynolds's Mill. 9 years old. September 13.
Diagnosis Inflammatory Pertussis

Rob. Terry's child. Nottingham. Died September 13. Dysentery
 Lived three days.

Geo. Raile's Child, Farmington. Died September 25. Diagnosis:
Pertussis.

September 13th, 1878 Geo. Cameron was killed today by the [railroad] cars!

Letitia Smith, (maid) Robert Gaines' house. Single. Died October 25, Diagnosis: Typhoid fever

Wm. Overholt's son Lawrence. aged 23 months. October 3.
Diagnosis: dysentery.

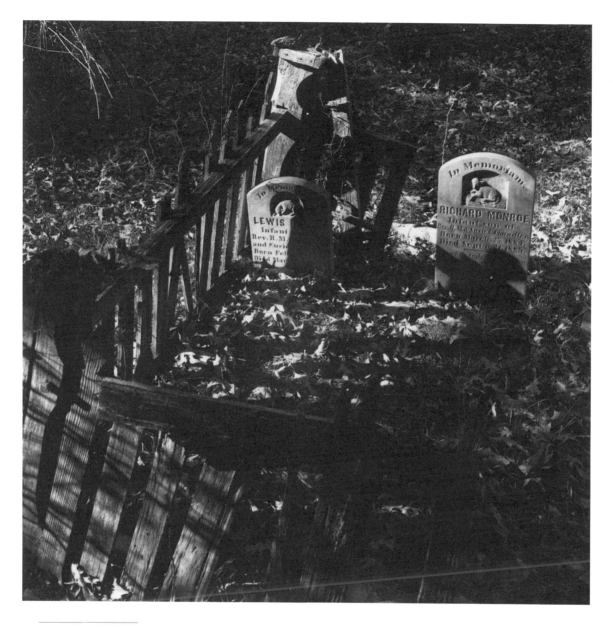

Bayview Cemetery,
Reedville, Virginia

[Mrs] Benj. Mahare and [infant child] Died December 1.
Mrs. Mahare's labor was an arm presentation. . . . the child died from pressure on the cord. Child weighed nearly 12 lbs.

George Reider, at Mary Pierce's [boarding house] Married. Died December 24. Diagnosis Typhoid fever.

Green Mount, Baltimore

꧁❦꧂

For the student of the odd and unusual grave marker, Baltimore's Green Mount Cemetery is a treasure. In addition to some truly remarkable markers, it holds a wildly varied collection of the famous and infamous dead.

Today, Green Mount is surrounded by urban decay and the quiet is pierced by the wail of sirens from surrounding North Baltimore, but when it was conceived as Baltimore's first rural (and pseudo-democratic) resting place in the 1830s, Green Mount was the country estate of mercantile magnate Robert Oliver.

As the Industrial Age spread across the urban American landscape, many of the old cemeteries and burial grounds connected with churches and ethnic groups were simply built over; others were so overcrowded as to have become health hazards. Often, in churchyards, the dead were buried one on top of the other in progressively shallower graves. At least one historian has partially attributed the urban outbreaks of cholera in the early nineteenth century to overcrowded city graveyards.

A solution that fit perfectly into both the death-as-romantic-sleep ideals of America and the new concept of public health was the garden, or rural, cemetery. The idea of using vast tracts of open land as large urban repositories for the dead originated with Mount Auburn in Boston, which opened for business in 1827.

Conceived not just as a burial ground, but also a landscaped park and center of culture, the first rural cemetery was imme-

diately popular, not just as a place in which to be buried, but as one in which to stroll, meditate, picnic, and enjoy the grounds and fresh air. Outings to the cemetery were such an attractive excursion that Boston soon added a railway line to Mount Auburn. It was not long before other cities, such as New York and Philadelphia, followed suit.

The rural-cemetery idea came to Baltimore around 1836 through the efforts of Samuel D. Walker, a tobacco merchant. After an inspiring visit to Mount Auburn, he came home and began to organize the local businessmen. They purchased sixty acres from the Oliver family and designated it as Green Mount Cemetery. In 1838, the state legislature voted to incorporate the cemetery.

Green Mount opened to much fanfare in 1839 and is still in operation to this day, although burials have dropped off sharply in the past twenty years as it has slowly filled up. An on-site crematorium, however, continues to operate behind the chapel.

Like other rural burial grounds, Green Mount was laid out with serpentine pathways, carefully landscaped in shrubbery and trees, then neatly divided into lots and plots. The architect Robert Carey Long designed the gatehouse and the Gothic memorial chapel, which has been recently restored. Green Mount was open to anyone, but the bottom-of-the-line price for a plot was $100 (about $2,500 in today's money), which limited patronage mostly to the white upper classes. Still, one notes the burial of beloved African American slaves and servants in the white family's plot, here as elsewhere.

Pricey though it was, Green Mount was an immediate hit. In fact, it became so popular that some purchasers of plots also imported their dead from other locations, as in the case of the Oliver family. Robert had originally been buried at Westminster but was moved to Green Mount, where he rests at the top of the hill known as Oliver's Walk. (Needless to say, the rich chose Oliver's Walk because it was one of the main avenues and a prime site for the display of fine monuments and mausoleums.) Another merchant, Robert Gilmor, started his long sleep out at Westminster and was transferred to Green Mount by an aunt who favored the fashionable new cemetery—but only for her

favorite relations. Those she was less inclined to favor still rest at Westminster.

One of Green Mount's better-known residents has no stone at all. Somewhere in the family plot in the Dogwood space lies the unmarked grave of Lincoln assassin and reputedly mediocre actor John Wilkes Booth. Booth was first buried at Navy Yard Arsenal in Washington, but at the entreaty of his mother and brother, popular Shakespearean actor Edwin Booth, his corpse was transferred here. Recent attempts to have the corpse located and exhumed for historical examination were not successful, so his exact whereabouts remain unknown.

Others, such as Elizabeth Patterson Bonaparte, are also remembered for the scandals they created. Betsy Bonaparte was the first, but not the last, Baltimore girl to marry into royalty. The local belle, daughter of the rich merchant William Patterson (namesake of Patterson Park, buried at Westminster), snagged Jerome Bonaparte, Napoleon's youngest brother, when he visited this country at the turn of the eighteenth century. Not a wise move. The marriage did not survive the wrath of the emperor, who had it declared invalid. Jerome, handsome, vain, weak, and rather dim-witted, allowed his brother to marry him off to a chubby Westphalian princess. Betsy did have time to produce a son, however, and spent the greater part of her youth and beauty dragging the boy around the Continent, trying to get herself and her child recognized by the Bonaparte family. But young Jerome Napoleon Bonaparte decided that he preferred American life and an American bride. His mother lived to a very old age as an eccentric, bitter miser, haunting the streets of Baltimore in her ragged black dresses, muttering how much she hated the town. She must resent being buried here, among the merchants and generals and other members of the haute bourgeoisie she despised so much.

"Monuments [in Green Mount]," notes Dr. Kent Lancaster in his monograph on the cemetery's history, "often reflect the tastes of the survivors more often than they do the tastes and character of the individual." Often, but not always; Aubrey Bodine, the *Sun* photographer who captured so much of the life and times of this region, is buried here, and his stone features a camera lens and his signature.

You wouldn't come to see me
When I was alive
Don't come to see me
Now That I'm dead

—Near Stockton, Somerset
County, Maryland
(stolen, present whereabouts
unknown)

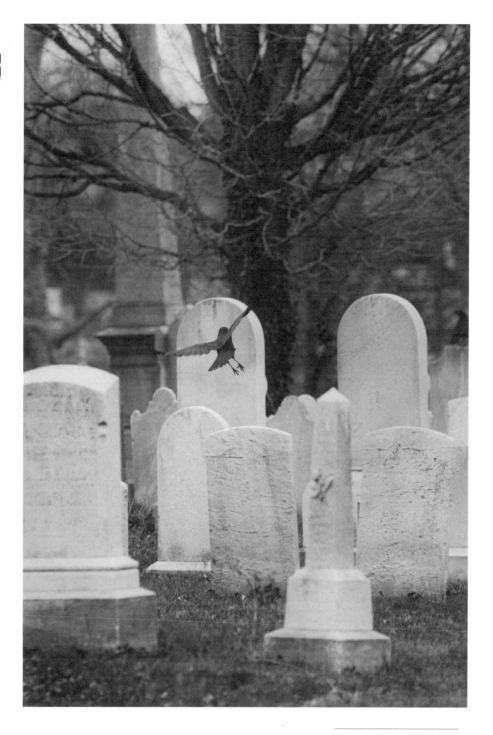

Green Mount Cemetery,
Baltimore, Maryland

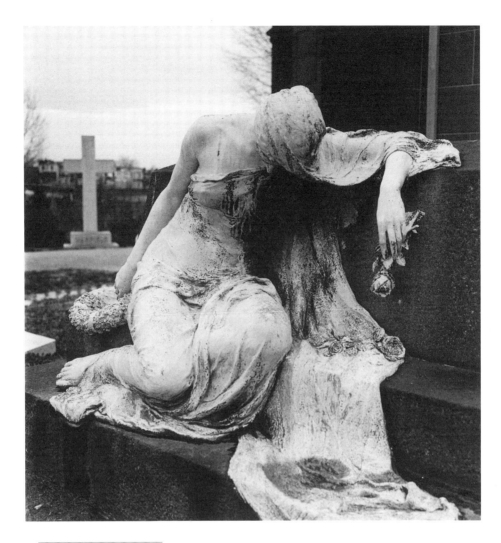

Green Mount Cemetery,
Baltimore, Maryland

Other unusual markers include an upside-down bathtub for a plumber named Crook, a mound of iron for a costermonger, a symbolically empty marble chair, and an allegorical statue that looks like Little Red Riding Hood.

Dr. Lancaster speculates on the meaning of the memorial for Mrs. John Pendleton Kennedy, wife of the senator and novelist. " . . . a lovely, romantic piece of sculpture—a young girl, unaware or perhaps too aware, that the faithful mongrel at her feet is looking up at her with love and concern, [while it] pins down a writhing serpent with its paw."

Either her dog saved her from a snakebite, or more likely, the dog symbolizes marital fidelity.

Green Mount also features some of the most interesting mortuary art in the region. William Henry Rinehart, founder of the Rinehart School of Sculpture at the Maryland Institute, sculpted larger-than-life figures for many graves here, including his own. His grave is marked with *Sleeping Endymion,* a handsome youth in repose, replete with a flute and a fig leaf. For the Walters family, whose accumulated treasures form the basis of the Walters Collection, Rinehart created a symbolic *pleurant* called *Love Reconciled with Death*; a Junoesque bronze woman dribbles flower petals across the family graves. *Grief,* created for the Riggs family, is another bronze *pleurant,* this time a reclining woman, heavily veiled and literally prostrate with grief.

Pleurants, or weeping figures, are common allegorical subjects in many cemeteries of the well-to-do, dating back to the Borgia popes. Most examples of the genre decorate the tombs of the robber barons buried in Sleepy Hollow Cemetery in Rhinebeck, New York, but what Green Mount's lack in quantity, they certainly make up in quality. Rinehart's figures have lifelike grace and style that other examples, say, by Washington's Saint-Gaudens, seem to lack.

Although they may appear a trifle grotesque or macabre to the modern eye, in the middle of the last century, allegorical memorials such as sleepers, *pleurants,* and angels were the height of status and style.

Maybe you *can* take it with you.

Irony is here, too. The floridly ornate crypt of *Sun* founder Arunah Abell was carved by noted artisan Sisson. This

Smith Island, Maryland.
Grave of a British officer
who died in the attack
on Baltimore in 1814.

crowded kind of high relief, full of floral motifs, was known as the wedding-cake style, and it does look like something that a young bride, rather than a newspaper publisher, would have chosen. It is so intricately carved and detailed that it must be covered with a plastic case to preserve it from both the elements and the seekers of souvenirs.

Interestingly enough, Sisson himself is remembered with only a plain obelisk. Perhaps his tastes—or his finances—were more restrained than those of his patrons.

The mighty Johns Hopkins sleeps here, beneath a plain flat Quaker slab, as does the poet Sidney Lanier. They share eternal space with soldiers and sailors, missionaries, merchants, and lawyers, prominent in their day and now merely footnotes to history.

Green Mount attracts attention for the wide range of monument styles represented within its gates. It mingles some of the earliest tablet and fiddleback stones, imported from older graveyards, with the ornate and imposing wedding-cake crypts so beloved of later generations and with the austere marble and granite stones popular today.

Oh, and if you're interested, there are still a very few spaces left in Green Mount. If you want to be buried with history, this is the place to do it.

Kids Just Know These Things

Four Graveyard
Ghost Stories from
Kristine Neaton,
Age 12

Kristine Neaton was a seventh-grade student at SS. Peter and Paul in Easton when she shared these stories with the author.

These stories aren't very long, is that all right?

The first one's about the half grave. Over in the corner of the cemetery in Easton, Cold Spring, there's this broken-off stone. It was broken in a storm one night, so they call it the half grave. It's behind the church in Easton, right? It's over by the caretaker's house, where they buried all the slaves. Okay. She, this lady, was a slave, and she was hanged. I don't know why—this is just what I heard, but she was a slave and she was trying to run away.

People go over there, and they sit on the grave at night. You have to go at night. It can't be during the day, because it won't work during the day. She only comes out at night. Anyway, if you go there at night and sit on the stone, she'll come out of the grave.

There's a tree near it, and a rope noose will dangle down from the tree if you sit on the stone at night. And she'll say, "Get off my grave!" and if you don't get off her grave, she'll come out and follow you, and it's really scary. Well, wouldn't

you think it was scary if you had a dead person following you?

And someone tried to replace the stone once, but it keeps breaking every time you try to replace it. Even if there's no storm. As soon as they put a new stone down, it breaks.

And they say, if you go there, down by the caretaker's house where the grave is, you can hear her down there, rolling around and yelling and stuff.

And they say that she gets her rope from the caretaker's place, because they're always missing pieces of rope out of there, when they come back in the morning.

They say that she goes inside the church sometimes, but I don't know about that.

The second one's not about the same graveyard, but it happened around Easton, too.

Back when they did stuff like that, there was a whole family, like ten people, and they got in trouble, and they were beheaded at the courthouse. The whole family, all ten people. Well, some of them were hanged and some of them got beheaded. This was a long time ago, right? I don't know what they did to deserve getting hanged or beheaded—that wasn't included in the story.

Well, they couldn't just leave them there, at the courthouse, so they threw them in the cemetery. They're all buried in the cemetery, anyway, but without any stones or anything because they were, like, criminals?

Anyway, the youngest one, Abigail, was a child, and she got beheaded. The ones who were beheaded got their heads back; that's part of the story.

And the whole family are these ghosts, who walk around Easton, and the ones who were hanged, you can see them at night, walking around with the ropes dragging along behind them. The ones who were beheaded, they walk around with their heads in their hands.

Abigail is the child, the youngest, and they beheaded her, and she walks around the graveyard and the courthouse yard with her head in her hands. And sometimes the whole family parades around the courthouse, okay?

Cambridge,
Maryland

Haynie Family
graveyard,
Haynie Point,
Virginia

They used to bury people in the courtyard, in front of the courthouse, but then they put all those ugly statues there and you can't see them anymore.

It's weird, but that's not the scariest part. The church part is the scariest part. Abigail haunts the church, too! Someone broke in one night, and they were going to break up the statues of the saints, but they saw Abigail sitting on the altar with her head in her lap!

And if you go in the graveyard, you know how they say that you can hear little ghosts going "Eeee, eeee, help me?" Well, Abigail's not little, I'm guessing, because she *screams*. She's going, like, "HELP ME," she's like "HEEEEEELP!" Like really loud. They say it's because she wants her head put back on.

But she screams louder and louder and louder, it's like a vicious scream? So, people say, "Where are you?" because they think she's a real person.

So she comes out, and she has this needle and thread in her one hand, and her head in the other. She wants you to help her sew her head back on, but who in their right mind would sew somebody's head back on for them? Who would help a screaming graveyard ghost put its head back on?

Well, down in St. Michaels, you know where that church is with the old graveyard, right on Talbot Street, right? Well, there are these two graves, and they belong to this waterman and his wife, okay? Well, on Valentine's Day—and I know this is true, because my friends, these kids I go to school with, live in St. Michaels and they told me they'd seen it.

Okay, what happens is, on Valentine's Day, this guy who was a waterman and drowned, he comes back, and his dead wife comes back. They had gotten divorced because he was really mean to her, so she pushed him off the boat, and he got stuck in a crab pot, and so he drowned. After they were both dead, the waterman and his wife got back together, and at midnight they get up from their graves and go in the church, and they like get married all over again, right?

They come in, and the man is like in his waterman's outfit, and the wife has her wedding dress on, and they walk around the church like normal people. They look normal,

but at nighttime they go back to being ghosts, and float around the graveyard, and they scare people. They don't go "BOO! I'm going to kill you!" but they scare people by surprising them. And you can tell they're ghosts.

And I know this is true, because my friends told me, right? And it's so scary, becuse the waterman carries crabs and stuff around the graveyard! I mean it scares me! Because every year they go down there, and one year, they left some crabs or some food on the tombstone, because the ghosts eat, and the waterman's ghost came out and ate them when they weren't looking! The food, I mean, not my friends!

Over near here, at Choptank, there's this graveyard near a big old house? That's where Bloody Mary haunts the graveyard and the house.

I don't know what she did to get killed, but they really, like demolished her! They say, if you're walking through the graveyard, watch out for her limbs, because the ghost parts of her are scattered all over and you can trip over them.

And there's this girl in my class who said that one of her friends was walking in the graveyard there? Her friend said to her, "Watch out, you don't want to step on Bloody Mary's fingers!"

But the other thing is, she follows you home, and you're in the bathroom, and if you look in the mirror and say "Bloody Mary" three times and you turn back around, she'll be standing behind you! And blood will come out of the sink and stuff! I think she comes back in the mirror because she was a nanny.

And then, there's all the stories about the trolls, but they aren't true.

HERE LIE THE ASHES OF DOROTHY PARKER

1893–1967

HUMORIST, WRITER, CRITIC

DEFENDER OF HUMAN AND CIVIL RIGHTS

FOR HER EPITAPH SHE SUGGESTED

"EXCUSE MY DUST"

THIS MEMORIAL GARDEN IS DEDICATED TO HER NOBLE

SPIRIT, WHICH CELEBRATED THE ONENESS OF HUMANKIND

AND TO THE BONDS OF EVERLASTING FRIENDSHIP BETWEEN

BLACK AND JEWISH PEOPLE

DEDICATED BY

THE NATIONAL ASSOCIATION

FOR THE ADVANCEMENT

OF COLORED PEOPLE

OCTOBER 20, 1986

Dorothy Parker? Yes, she's buried in Baltimore.

For years, her ashes sat on a shelf in the law offices of New York politico Paul O'Dwyer, who was also her attorney. Parker, a great admirer of Dr. Martin Luther King, had bequeathed her estate to the Civil Rights leader, then to the National Association for the Advancement of Colored People.

Her ashes now rest beneath the pines at NAACP headquarters on Mount Hope Drive.

Oak Hill and Rock Creek

Washington unarguably dominates graveyard society with its landmark remembrances of lives past. Of all its garden cemeteries, Oak Hill is among the oldest and most ornamental, and for that reason alone it deserves mention here. Rock Creek Cemetery, too, is definitely worth going a bit out of one's way.

In large urban areas such as Washington and Baltimore, which are home to many generations of well-to-do families, it is not uncommon to find elaborate mausoleums, miniature temples, shafts, huge cenotaphs, ersatz Greco-Roman sarcophagi, larger-than-life *pleurants,* angels, and other allegorical figures. Most of them date from the beginnings of the great American fortunes, when a handsome mortuary monument was the *ne plus ultra* in status symbols. In these granite and marble cities of the dead, Victorian excess is at every turn.

Too much of a good thing can quickly send the cemetery visitor into sensory overload, but there is something about Oak Hill, now slightly shabby in its overgrown plantings and shady layouts, that hints at its original charm. Certainly some prominent citizens appreciated Oak Hill's ambience even before extravagance set in.

An early eighteenth-century Washington mayor, John Van Ness, for instance, chose a round Greek temple, high on the hill, for his family's mausoleum. Maybe the site fired a classically educated imagination and made him hope for esthetic dominance over generations that followed. If so, it is well that the mayor cannot see what has happened since.

A somewhat mediocre sculptor but better self-promoter, Victorian John Joyce (1842–1915) is buried here beneath a likeness he created of himself. Joyce also fancied himself a poet, very much in the Edgar A. Guest style, and spent a great deal of his time suing those whom he considered plagiarists of his verse. A few years before his death, he erected his own stone and happily posed with it. Naturally, his own poetry serves as his epitaph:

> Vain, vain is the thought; no man ever brought
> Exemption from final decay;
> To live and rot and then be forgot—
> The fate of the quick of today!

No epitaph marks the Adams Memorial at Rock Creek Cemetery and perhaps no written word is needed. In a scraggly holly grove, a weathered, heavily draped figure, seated before a marble slab, seems to stare out at the unwary tourist. It is just a trick of the light, but to come upon it suddenly is almost to believe that there are glittering pupils in that verdigris face.

Others have remarked upon the haunting quality of this *pleurant*; Eleanor Roosevelt was one frequent visitor who remarked about the oddly alluring statue's hypnotic aura of vast sorrow and mourning. The allegorical piece, often called *Grief*, does seem to project a feeling of great melancholy and tragedy, even within earshot of busy traffic from Rock Creek Parkway.

Naturally, legends about ghosts and haunting have attached themselves to it. District college students say that the statue's eyes glow in the dark if one comes to visit it at night and that, on certain nights of the year, it audibly moans and groans in great emotional pain.

Commissioned from the noted nineteenth-century sculptor Saint-Gaudens by eminent historian and intellectual Henry Adams, it was created to mark the burial site of his wife, Margaret Hooper "Clover" Adams. Clover Adams is supposed to have killed herself following the death of her father, with whom she shared an intensely close relationship. Whatever the cause, Adams never spoke of it and in his autobiography, *The Education of Henry Adams*, never mentions her at all.

Suicide, to the Victorians, was an unspeakable disgrace, an unmentionable act. An intellectual, intensely proud of his descent from two presidents, Adams must have regarded his wife's death, whether actually or only reputedly a suicide, as a blow upon a bruise. Perhaps that is why there is no epitaph. He disliked the statue's being called *Grief* and referred to it as *The Peace of God.* Saint-Gaudens is said to have used his apprentice, draped in blankets, for the model of the work. Its disquieting androgynous quality and the patina of age compound the emotional feeling of the piece.

Among all the generic marble angels, mourners, *pleurants,* and allegorical figures to be found in Chesapeake country, this is the real thing, a genuinely evocative piece of art that generates in the viewer a strange feeling of loss and sadness.

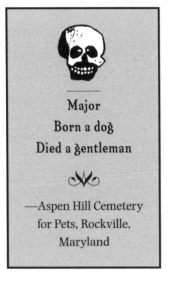

Major
Born a dog
Died a gentleman

—Aspen Hill Cemetery for Pets, Rockville, Maryland

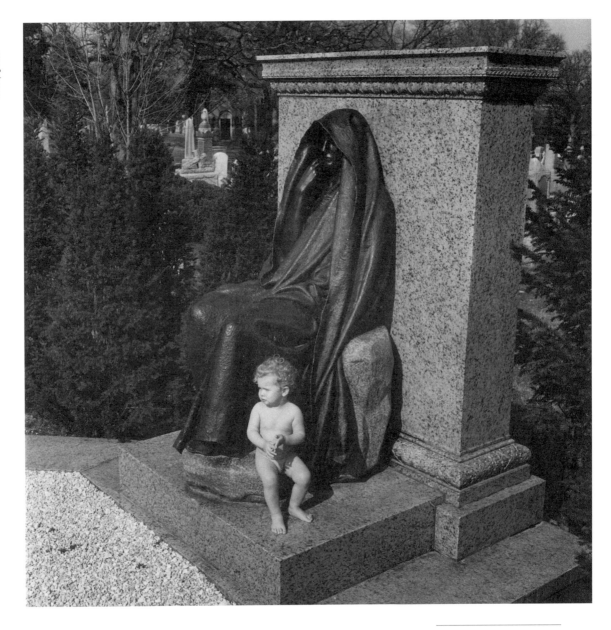

Clover Adams gravesite,
Rock Creek Cemetery,
Washington, D.C.

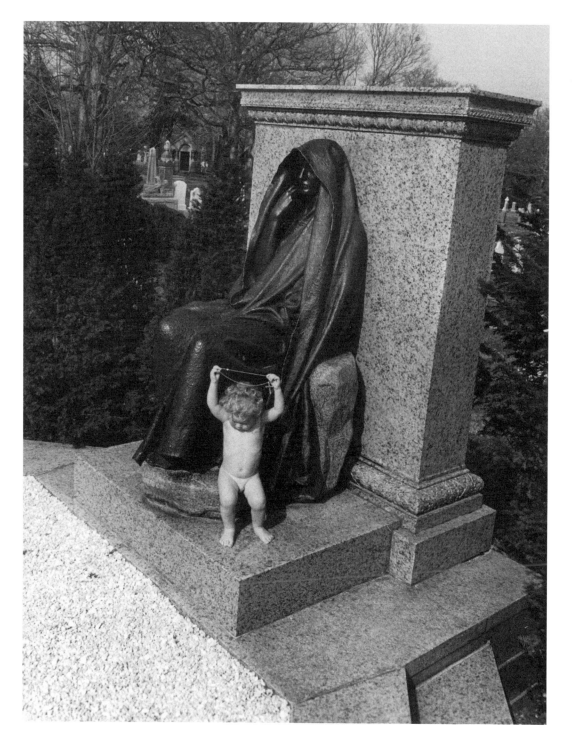

Scott and Zelda

Beautiful, doomed, talented Scott and Zelda.

Champagne, jazz; bathing in the fountains at the Plaza Hotel. Parties and bootleg gin. Paris in the Twenties. Celebrity and the grace of great good fortune. This is the spun sugar from which legends are made.

And then, the party's over. The slow, inexorable descent into despair and depression and madness and alcoholism. Hollywood and mental institutions.

Scott Fitzgerald said there are no second acts in American lives, only because his own was so terrible. But oh, Act I was divine while it lasted.

The great era of the Romantics that had begun with Shelley and Byron ended with Fitzgerald's death in his mistress's Hollywood apartment on December 21, 1940. Scott was 44.

Zelda lived on in the gardens of madness with her own ghosts until March 11, 1948, when she was killed in a fire that swept through the asylum that housed her, but what had made Zelda unique had long since fled.

It's all the moon madness, the cobwebs of legends.

Scott *wanted* to be buried in Maryland. *I belong here, where everything is civilized and gay and rotted and polite,* he wrote. *And I wouldn't mind a bit if in a few years Zelda and I snuggle up together under a stone in some old graveyard here. That is really a happy thought, and not melancholy at all.*

Because he was not a practicing Catholic, he was refused burial at St. Mary's Cemetery in Rockville, which had been his first choice. He and Zelda were buried at Rockville Union.

Thirty-five years later the Church relented, and today Scott and Zelda snuggle up together under a flat stone at St. Mary's.

The epitaph on the Fitzgeralds' stone, taken from *The Great Gatsby,* arguably his best novel, reads:

> So we beat on, boats against the current, borne ceaselessly back into the past.

Listening to the traffic roar over Rockville Pike, it's hard to read that line and not to feel both awed and saddened.

Writing in the *Washington Post* on September 24, 1996, the 100th anniversary of Scott's birth, Henry Allen mused upon the fascination that the Fitzgeralds still exert. Somewhere in his travels, Allen had run across an undated clipping that described the Fitzgeralds' exhumation and reburial. One of the exhumers had opened the coffin to ascertain the correct identity of the dead. Apparently, Scott was instantly recognizable by the Brooks Brothers suit he had been buried in.

"It had held up quite well," Mr. Allen noted.

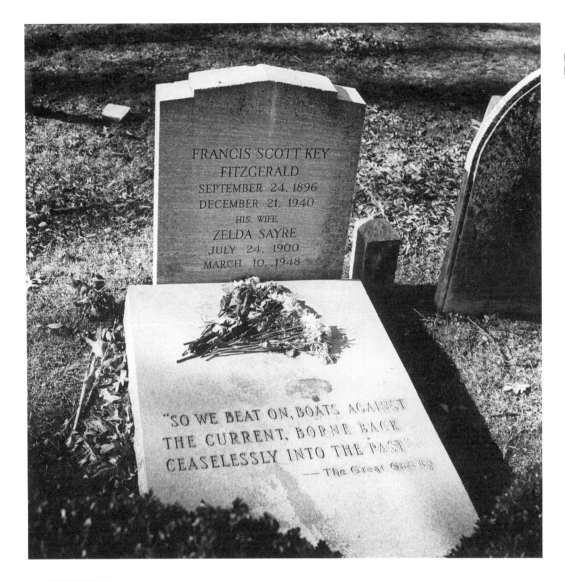

F. Scott and
Zelda Fitzgerald
marker, Rockville,
Maryland

Floating Coffins

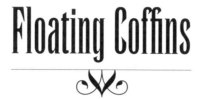

In the marshy Chesapeake regions, it is not uncommon to see graves weighted down by brick arches covered with cement slabs, or tombs built up in brick boxes with table slabs sheltering the grave. There's a good reason for this. In times of flood, water could saturate the marshy ground and float an old wooden coffin right up to the surface.

This is the story I heard as a child:

An old waterman died and was buried in the cemetery at Fishing Creek, right before Hurricane Hazel tore through. Most of the island was flooded, and the water was coming up into the first floor of people's houses. The bereaved widow, hearing a knocking at her front door, waded through the house to answer it. There, she found her husband's coffin, bobbing gently on the flood, tapping at his own door.

From beyond the grave, he'd found his way home.

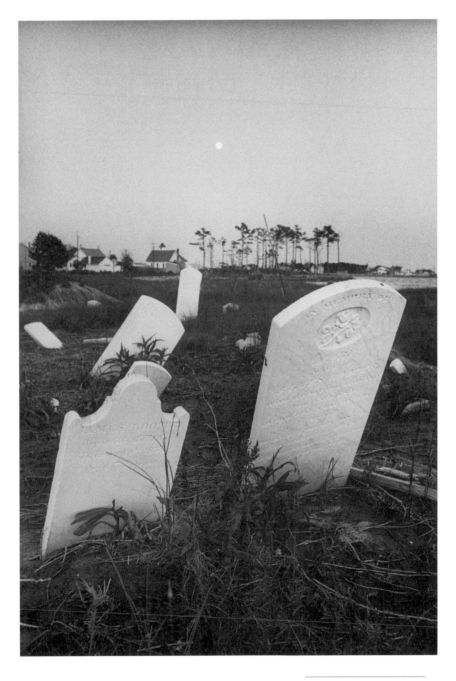

Lower Hooper's Island,
Maryland

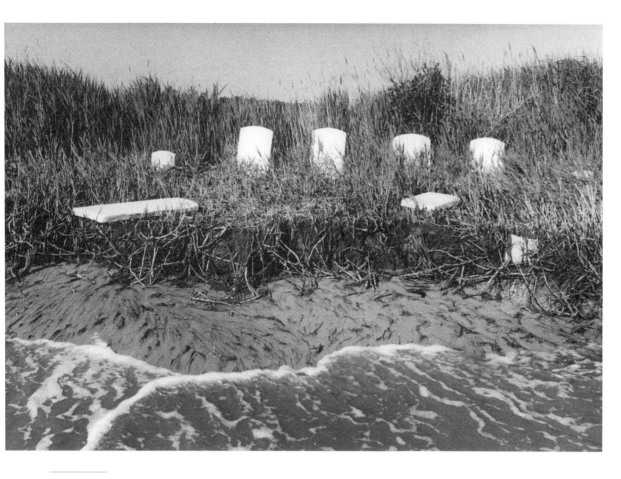

Crocheron,
Maryland

Arlington National Cemetery

The District of Columbia has more than its fair share of both monuments and distinguished dead. Arlington National Cemetery, created during the Civil War from Robert E. Lee's confiscated property across the river in nearby Virginia, is probably the most famous burial site in America. The Unknown Soldiers of four twentieth-century wars are entombed at Arlington, along with 2,111 unidentified Civil War soldiers, buried here in a mass grave.

Some very famous captains and kings are also buried at Arlington. The monarchs of Camelot sleep here; assassinated President John F. Kennedy, his wife, Jacqueline, their baby son Patrick, and JFK's murdered brother, Robert Kennedy, are all interred at Arlington. Generals Black Jack Pershing, Omar Bradley, George Marshall, and Phillip Sheridan, as well as Admiral Richard E. Byrd and Commodore Matthew C. Perry, await their final judgment in the company of Oliver Wendell Holmes, Jr., Dr. Walter Reed, presidential wannabe William Jennings Bryan, and President William Howard Taft.

Veterans from every branch of the military service and their spouses may request burial here, and many do. This is the place where one expects to find national heroes like civil rights leader Medgar Evers and "Wild Bill" Donovan, founder of the OSS, later to become the CIA.

Unexpectedly, Arlington is also the final resting place of blonde actress Constance Bennett, mystery and suspense novelist Mary Roberts Rinehart, and hardboiled detective fiction writer (and Maryland native) Dashiell Hammett.

This world, a city full of crooked streets
Death is a marketplace where all men meets
If Life was Merchandize that men could buy
The rich would live ever, only poore men dye

—Green Hill, Wicomico County, Maryland

One That Got Away

Sometimes you hear about these wonderful, these *legendary* tombstones—stones that are unique, that are just what one would want for a book like this. No one ever knows exactly where they are, but your informant has always heard of them through that odd rumor, on a chain descending from a friend of a friend of a friend.

But that friend of a friend, once you find him or her at a crossroads store or a gas station or a post office, never quite knows where these grave markers actually are, either. These sources think that the stones might be here, or there, or even somewhere else entirely, maybe.

Long searches through burial sites and graveyards turn up nothing even vaguely close to the legend. Like Excalibur or a mirage, the wonderful stones always seem to be very close, yet just out of reach. The trouble is, most people who happen upon a wonderful stone will stop, take note of the oddness of the thing, and then promptly forget about it.

This is especially true of tombstones rumored to be very old. When someone promises you some markers that go back to the 1600s and you slog through woods, wetlands, and muddy fields only to find that the oldest stone in a forgotten and overgrown graveyard dates from 1937, well, you become cynical. Jaded. Tired.

Some stones that I have sought in vain wait in a cemetery described as full of monuments engraved with workboats and eighteen-wheeler trucks. Where are they? *Are* they at all, or did

my informant have a little too much chemical fun in the sixties and create them in his mind?

But it's the old sailor who was buried in his hammock who has proved the most frustrating and the most elusive.

The story is that the crusty old salt was laid to rest in an old churchyard in the hammock he slept in during his seafaring days. The hammock was suspended from the flat slab that covered the grave, or so the epitaph is supposed to have said.

In the fragile hope that this sailor might have made landfall in Southern Maryland, I searched long and hard and never found him. A couple of people had heard of him, in a vague sort of way, but no one knew where he might be, not even the tombstone ladies.

Perhaps his marker was stolen by souvenir hunters. Perhaps it has weathered away. Maybe he never existed. Or, as I sometimes think, maybe he just didn't want his hammock rest disturbed.

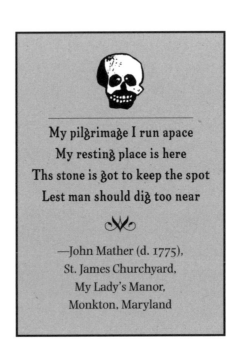

My pilgrimage I run apace
My resting place is here
Ths stone is got to keep the spot
Lest man should dig too near

—John Mather (d. 1775),
St. James Churchyard,
My Lady's Manor,
Monkton, Maryland

Larger than Death

Tallulah Bankhead

She once described herself as "pure as the driven slush." When people remember actress Tallulah Bankhead, it's rarely for her work on Broadway and in Hollywood. It's the larger-than-life legend that her name evokes: the men, the booze, the parties, the drugs. She once said she called everyone "darling" because she couldn't remember whom she'd slept with and whom she hadn't—yet.

Tallulah would have enjoyed the irony of finding herself sleeping among the privileged, private, Protestant elite at St. Paul's Episcopal Church near Chestertown. But after all, this Alabama senator's daughter is one of them, deny it though she might have in life.

Tallulah's sister, whose country estate was nearby, provided this final resting place for her prodigal sibling, who died broke but, one hopes, fulfilled, in 1968.

On Death and Burial

❧❦

A Conversation
in a Country
Store

This passage, taken from oral histories of South Dorchester County, is probably representative of the fate of many abandoned grave sites of the rural poor, black and white, throughout the region. Countless grave sites, both African American and European, have "disappeared" beneath asphalt. Malls, highways, and housing developments have all taken their toll.

People used to die, they just nailed up in a box and buried 'em wherever they could. They didn't have too many regular graveyards or no vaults in them days. They just buried people on their own property. You can't do it no more. You ain't supposed to, anyway.

You ain't supposed to tear up no graveyard, either. They're pretty heavy on you now if you do that, but years ago, they done it plenty. At Shiloh, there used to be a store. They built that store right on top of a graveyard. The mailman that come through here had people buried there. He raised the devil, but they done it anyway. Just laid the tombstones down and built right over it.

From *Conversations in a Country Store*, by Hal Roth (Nanticoke Press, 1995). Used with permission of the author.

And where the canning house is, a right smart graveyard there. I think they were all colored. There were some tombstones all out there. I don't know what they done—pushed it into the woods or what. They had bulldozers out there leveling it up, and the graveyard disappeared.

The old ones what lived all over the place in tenement shacks, when one of them died, they just buried them where they could. They didn't have no money or nothing. They buried a lot across the ditch. I know they tore up many a grave in there when the electric people run that line through. Ain't but one tombstone left, and it's down in the branch. I think there's one vault. The rest they just put in a box.

I remember when one died in the house that's still standing over there. His neighbor come and said the undertaker wouldn't bury him till he gets some money. They'd kept him up about a week or so, then already. I said, "Well, I've give some, but I can't pay for the whole burying." The county or the state wouldn't give nothing in those days. So we give a little something on it, and some other people give a little something too. And they sold a hog he had in the pen there, and they put him out. He's over in the branch. That's where they put him anyway. I can't say where he's at now. Them bulldozers the electric crowd sent in there might have scattered him everywhere. They just drove over the colored cemetery, but they didn't hit the white one in the woods.

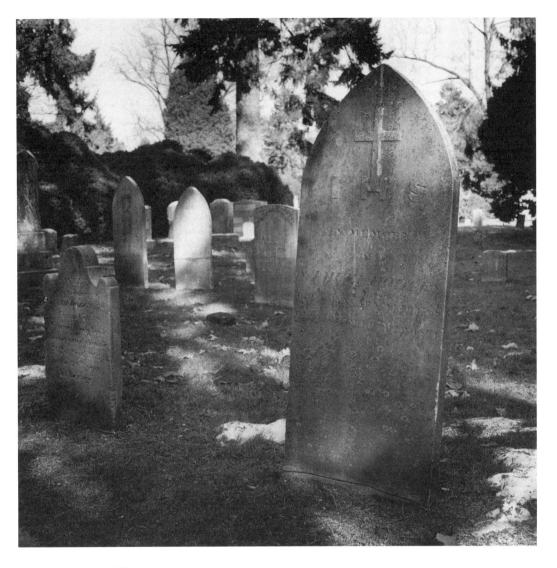

St. James Church,
Rock Hall,
Maryland

Old St. Paul's Cemetery

As famous as Presbyterian Westminster and equally stuffed with prominent dead Baltimoreans, Old St. Paul's Cemetery today is a shadow of its former self. It has shrunk considerably since its glory days at the turn of the eighteenth century, when St. Paul's was *the* church and its burial ground *the* resting place for the city's Episcopalian elite. To ancestor-proud Baltimoreans, St. Paul's doesn't need unusual or intriguing features; it earns a certain distinction by virtue of its age and its denizens. For the rest of us, its quaintness is its main attraction.

Not everyone buried here was rich and well connected, although the genealogists seem to enjoy the southeast section along what is now Redwood Street. According to Kent Lancaster, who has made a study of the cemetery's history, Old St. Paul's had no objection to burying "outsiders" as long as they could pay the $10 fee and didn't mind a less socially prominent resting place. He notes that suicides, generally denied admission to consecrated ground, were accepted here by the rectors. Even executed criminals were acceptable; at least one convicted murderer and two executed pirates appear on the parish burial records, although their exact burial sites are not confirmed.

Aesthetically, Old St. Paul's lacks the drama of its rival, Westminster. It has neither catacombs nor Edgar Allan Poe to boast of, and its monuments are rather mundane, consisting mainly of the tablet marker, the broken column, and the marble slab, often in poor shape or restored. There is, however, one garish red sandstone Celtic cross, a monument to a deceased rector,

that stands out among these subdued and conservative stones.

Old St. Paul's, like Westminster, features barrel vaults; a be-low-ground crypt is topped by a brick archway which in turn was covered with sod and encouraged to grow grass. The vaults are fronted and closed with facades that range from red brick through marble to granite. Overall they display the transition of funerary fashion from restrained Federal to Neo–Beaux Arts. Apparently, the barrel vaults were built to accommodate the family's accumulating ancestors. Earlier burials were often dis-interred and reinterred in the vaults along with later arrivals. The markers of the previously deceased were sometimes dis-played around the new vault.

Underground vaults, accessed by heavy iron doors laid flush with the earth, are one of the more interesting features of this cemetery, although many of the doors have long ago dis-appeared into the sod.

Thirty years after Old St. Paul's was opened, it had become an anachronism. The fashion had moved toward the rural cem-eteries like Green Mount then springing up around the city and county, and both burials and maintenance began to decline.

Dr. Lancaster points out that for the next century there were continual reports of neglect, vandalism, and crime associated with Old St. Paul's. What had originated as a suburban parish became a fashionable urban area, then began the slide into a century of decay. Weeds and greenbriar overran the burial yard. Tombstones fell over or were damaged by vandals. Gaping holes were left in the ground after people removed their dead to other locations.

As with Westminster, winos and junkies found the vaults easy to break into and good places to sleep, out of the weather. This Dickensian development was vividly illustrated when the vault of the John Edgar Howard family was set afire. Newspaper accounts gathered by Dr. Lancaster report that broken coffins, bones, skulls, and military relics lay in a waterlogged mess in-side the vault for all the world to see and plunder.

From time to time, indignation and concern for Old St. Paul's Cemetery would cause a flurry of protests and meetings, but lack of money and consensus generally discouraged any con-crete attempt at restoration. Then, in the 1950s, when the city

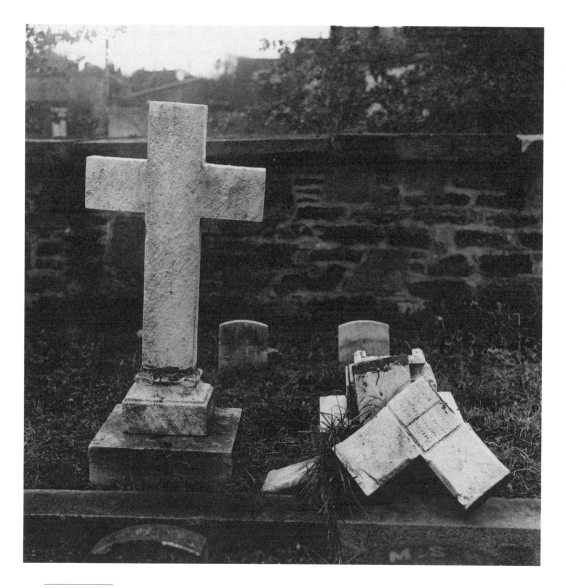

Old St. Paul's
Cemetery, Baltimore,
Maryland

planned to demolish the cemetery for the East-West Highway, the controversy raged again. The St. Paul's vestry sold the western portion of the cemetery to the Department of Public Works and relocated its remains and monuments to the space that was left.

Today, Old St. Paul's (at West Lombard and Pine streets—open Saturdays) is better maintained than it has been for the past 150 years. The city and the parish, recognizing the cemetery for the cultural and historical landmark it is, have placed it among the three best-known burial grounds in Baltimore. For that reason alone, it is well worth a visit.

Arvel Johnson on His Native Soil

The November sky is gray and ragged with torn clouds as Arvel Johnson emerges from the Dorchester County Detention Center, notebook in hand. He is the county's Community Service Supervisor, and his job is to direct those who have been ordered by the judges to work off their offenses.

"You know," he's explaining in the verbal shorthand familiar to anyone who's ever worked in, or reported on, the Maryland legal system, "the non-violent offenders. DWIs, FTAs, deadbeat dads, non-performers [of contracts], failures to pay. Those kinds of people."

We climb into his enormous truck as he continues, "And, if they happen to be working, say, a highway crew near a graveyard that needs some attention, well, I have them clear out the bush and hack away the briars there, too." He chuckles at my question about the offenders. "I had a twenty-year career in the military. I don't pay [disruptive behavior] as much attention as some people would. I'm used to an all-male environment."

Arvel Johnson is a man with a mission. He wants to preserve and protect all the abandoned and neglected cemeteries in the Lower Shore region, but most especially those in Dorchester County. The small grant he has received from the state comes through the Maryland Historical Trust, and it lists him as the Eastern Shore Historical Association. As laid out in his grant proposal, the idea is to restore old graveyards; gather oral and written documentation from elders in the area, both alive and deceased; publish a newsletter; provide employment for stu-

dents; promote interaction between young and old through project involvement; and further better understanding of African American cultures by documenting and preserving old African American graveyards and burial sites.

African American history, after years of neglect and patronization by establishment historians, is, you understand, suddenly fashionable. No doubt it has been made so by the saturation coverage of the dead, European, and prominent among us; African Americans are the last undocumented ethnic group. Perhaps it is inspired by Alex Haley's book and TV miniseries *Roots.* To my mind, the only tragedy about this renaissance and research is that it has taken us so long to get to it.

"Don't have to be African American," Arvel assures me, as we head out of Cambridge and down toward the Neck District, "but to get the grant, we needed to stress that." The grant was received in conjunction with a similar project sponsored by Mt. Olivet A.M.E. church in Fruitland, that covers the same mission in Wicomico County.

To his mind, people are people, he says, and we all have to get along. And among those interred in the graveyards that need rescuing, one hopes that worldly matters like race have long since ceased to be a concern. Or so these two Dorchesterians, one native, one raised up here, want to agree.

Today's mission is to find a tombstone marked RAMBO. Someone told him about it, and we're off to see if we can locate it in a garden cemetery just west of town, not too far from where I grew up. These are the kinds of missions I like; not only do they involve locating a certain stone, but I get to meet and talk to some of the most interesting people around—those with what I've come to think of as "graveyard minds," after the Bo Diddly song.

Arvel definitely has a graveyard mind. As he drives, he talks about the things that led him to this mission. A native of Crapo, a small village "down below" the edge of the Great Dorchester Marsh, he says, "I was raised among old people. I had come home for a funeral, and as the service was going on, my attention drifted a bit. I bent down to pick up a piece of clay from the grave and saw, through the crack in a vault, that I was looking at a cadaver. Down below, it's so marshy that ground water will

African American
grave, near Hooper's
Island, Maryland

seep right into the concrete vaults. Then, when it gets cold, it freezes and cracks the concrete. It seemed unfitting that it should be like that, that the graveyard should be so neglected."

A lifer in the army, with two tours in Vietnam, Arvel somehow conveys the feeling that he's had a personal encounter or two with death himself. He retired from the military and spent several years working in the state correctional system. Then, when he retired from the state, he came back home to the Eastern Shore and took up his job for Dorchester County. At home, among his own people once again, he found that his mission began to take hold of him. He's worked, he says, since he was five. You know he won't stop now; this is a man who likes to be active, who likes to have a project. Indeed, paperwork for this project fills the back of his truck; ask for information or documentation on something, and Arvel's arm goes over the seat, moves about, and comes up with just what is needed. His eyes never leave the road. "My wife says I could live in this truck," he chuckles. "I've got everything here I need. Change of clothes, water, everything." Triumphantly, he hands me a copy of his grant form.

So far, his dream to have some of Dorchester's high school kids perform their mandatory community service by cleaning up, restoring, and documenting the thousands of abandoned grave sites around the county hasn't come to fruition. However, the project may well prevail over stiff-necked administrators and other "suits" who lack Arvel's vision.

Arvel isn't limiting himself to high school kids, either. He'd like to involve middle-schoolers and college kids, too. And it wouldn't just be going out and whacking the brambles away from old graves. There would be oral history, collecting, and documentation projects that would link the kids of the county to their living past. This idea, he thinks, can benefit everyone, young and old, black and white.

"The way I see it, a project like this teaches kids pride, citizenship, and community responsibility," Arvel points out. "They also learn civics, history, mathematics, and photography. They'd learn to interview people."

It has started to rain; a thin sullen misty precipitation that turns the cool air humid. Arvel's windshield wipers make a

contrapuntal harmony with his conversation.

"I used to get homesick," he confides, "so I'd go down to Crapo to visit the tombstones."

Green Mount (not to be confused with its Baltimore counterpart), the graveyard where Rambo is allegedly buried (are you listening, Sly Stallone?) heaves up beside us. It is the sort of medium-sized garden graveyard one finds in small cities across America—the kind where you might expect to find your grandparents or even your parents, not to mention the kid who cracked up his car against a tree your senior year, peacefully slumbering in row upon row of marble and sandstone markers. Sometimes such sites are punctuated by the odd cenotaph or broken column or something else really fancy, but mostly it's the marble markers you recognize. We park and scout the stones, but no Rambo immediately catches our eye.

By now, it has begun to rain in earnest, cold November droplets that cling to the windshield and slide down the glass like tears. Arvel, deciding that I'll probably melt in the wet, bids me to stay in the warm truck that smells faintly of aftershave. In a quick dash, he's out of the truck and running down a row, toward the place at the end where his informant said he *thought there was this stone that said Rambo,* which is the sort of tombstone directions one all too often receives.

Levin Davenport was quite a character. He lived down to Cokeland, down below and he more or less kept a store there. But you'd see him out to all the auctions, and sitting around with the boys, like, and he wouldn't have on any shoes, just these rags wrapped around his feet. Oh, he were something; everyone who knew said so.

When he knew he was dying, he said, Well boys, I want Smokey the Bear on my tombstone, and that's what he got. You can see the stone over to the cemetery in Vienna, next to that little boy who got killed across the river by that crazy man.

And all too often, like now, they turn out to be vague and inaccurate. Most people don't pay more than a passing degree of attention to tombstones.

After a couple of vain moments spent getting wet, Arvel returns to the truck. "I guess it's out there somewhere," he says, disappointed, "but we aren't gonna find it today, are we?"

As we drive in the rain past Spocott, the restored plantation with the working windmill, I point out that when I was a child, this place was not a historic plantation but a general store run by Mr. Burns, whose character and hygiene my mother found so distasteful that she refused to trade there and instead took her business to Mr. Lewis's store on down the road in Cornersville.

Arvel chuckles. "Mission," he tells me. "The name of that place is Mission if you're black and Cornersville if you're white." Of such small social codes is life on the Eastern Shore composed; I never quite get used to it.

We turn up Ross Neck Road, and about a quarter of a mile up, Arvel points to a thick, dense stand of old pines. "There's an old African American graveyard back in those woods there," he says. "When deer season is over, I intend to get back in there and look for it. That's one of the places I want to take the kids, if I can find it. It's long ago abandoned. Those woods have grown up all around it."

Since there's no use trying to get to it today, we go on up the road and I show him the graveyard beside the house where I grew up. Naturally, it's all grown up, too, and heavily forested now. "I doubt anyone's been back in there in thirty years," I say. "The new people, who bought the farm from my father, are from Washington or Philadelphia. I doubt they even know that it exists."

But Arvel notes the spot, and promises that he'll talk to the farm manager about seeing it one of these days.

On the way back up the road again, Arvel says, "You know, I was supposed to go down to Vienna today and I forgot all about it. I was going to stake up a graveyard down there for an old lady in Cambridge. They're her family, and I said I'd go down there today and look into it."

Hard to beat

—Epitaph for Annie Cordes (d. 1881, aged 32), Bethel Methodist Church, North East, Maryland

Well, they said old man Cordes beat his first wife to death, but Annie, she wasn't havin' none of that!

Nonetheless, we stop again on Hudson Road, this time to explore a small African American graveyard that once belonged to a church. The church is long gone, and the graveyard is disappearing fast. Its outer edges are slowly sinking into the wetlands, the old graves around the outside falling in. Many have no headstones now, if they ever did. Others are simply marked with large chunks of rock, which is somehow even sadder.

As we wander around, I laugh at someone named Odious, who served in World War I, but Arvel doesn't think Odious is a funny name, even when I tell him one of my ancestors was named Mourning.

"Look at this," Arvel says, and I stop to peer at a marble stone adorned with a photographic image, preserved on a ceramic tile, of a pretty, smiling young woman. Her name and epitaph are written in French. Her name was Nelle, it says. She died in the sixties, but there is no birth date given.

"She rests with God, *Dieu.*" I translate her epitaph lamely.

"She lived in Paris," Arvel says, and I wonder if he knows this for fact or legend, or if he's speculating. But I really don't want to know. I want to believe that this pretty young woman somehow escaped from all the dreary racism and provincial poverty of the Eastern Shore. I want to see her leading a wonderful life, *à la* Josephine Baker, in Paris, where her talent—for she must have been talented, I insist to myself—inspired the French to treat her like a queen. I want to believe that she lived to be a very old lady in one of those marvelous old apartments in Ste. Germaine and that, when she died, her will informed those French lawyers that she wanted to be sent home and buried in her native soil.

I imagine the service in this little roadside graveyard, even back in the sixties abandoned and forlorn. I see the handful of mourners who knew Nelle as a girl, and I see the flower arrangements, some of them cabled to this sleepy Shore town all the way from Europe. I see the mahogany coffin with the bright brass fixtures and hear the brief service as the minister consecrates her body to the soil and her soul to God, with the Choptank River just a few hundred yards away.

Her bones have come home and her soul is at peace.

Bayview Cemetery,
Reedville, Virginia

For Nelle, it's not the reality that I want; it's the romance that I've spun in my head. Hers is the latest stone in this graveyard. Surely there is a story here, but I like my own better.

Arvel has turned away, for it is raining again and that old lady in Vienna is on his mind. Quickly, I follow him to the truck and the long drive back to town.

"Now," he says, once we're on the road again, consulting his list, "if I can just find Sir Anthony Manning, 1754—. Now there's a story."

And he's off on another mission.

St. Mary's White Chapel,
Lancaster County,
Virginia

Miss Olivia and Miss June

Miss Olivia, she was ancestor proud. She was a direct descendent of some general or someone who held George Washington's hand at Valley Forge, and she belonged to every Daughters group there was. Of course, since then, the family hadn't amounted to anything and was steadily going downhill from there. They had a little house over near Saxis that was falling down on itself. But Miss Olivia and her sister June must have crawled through every outback cemetery in Accomac County, writing down the names and dates.

Now, back in the old days, they used to take the dead out and bury 'em alongside the house, out in a field, and then, after a while the whole family would die out and they'd sell of the property, and the new owners would just let the little family cemeteries go, all overgrown and decrepit, so they were grown up in weeds and greenbriars and black walnut trees. But that never stopped Miss Olivia and Miss June. What a pair they were! Two old ladies, and they was bound and determined to record every old tombstone in the county—I think they damn well near did—and wrote 'em all up in a book that's at the library. If you're looking for your dead relations, you can go in there and see it in that book. And it's all because of those ladies like Miss Olivia, crawlin' through those weeds.

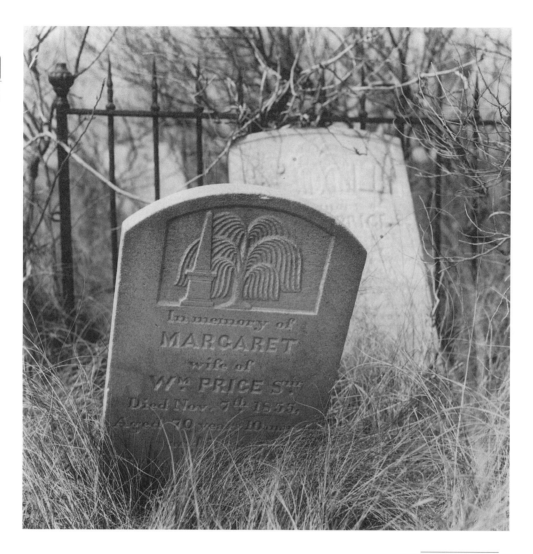

Holland Island,
Maryland

Bayview Cemetery,
Reedville, Virginia

Paying Our Respects to Mr. Poe

The actor of talent is poor at heart indeed, if he do not look with contempt upon the mediocrity even of a king. The writer of this article is himself the son of an actress—has invariably made it his boast—and no earl was ever prouder of his earldom than he of the descent from a woman who, although well born, hesitated not to consecrate to the drama her brief career of genius and beauty.

—Epitaph of Elizabeth Arnold [Allan] (d. 1811, aged 24), buried in St. John's Churchyard, Richmond, Virginia, written by her son, Edgar Allan Poe

It was one of those gray winter days that have teeth in them when we drove up to Baltimore with one of Michael's paintings in the back seat. Michael wanted to leave it on Edgar Allan Poe's grave as a present for the dead writer. This mission would take us to Westminster Burying Ground.

I've always identified with Edgar Allan Poe. Like many writers, he was handed a talent and a short stick at the same time. Used up by greedy publishers, underpaid as both an editor and a writer, slandered by those who were supposed to be his friends, Poe had a rough, short life that ended in a Baltimore charity hospital.

Poor Poe. In life, he suffered and starved for his art, and now that he's dead and in the public domain, the poor man is a ma-

jor industry, making a lot of money for other people. The exploitation started within nanoseconds of his miserable death. One Reverend Griswold, who had claimed to be his friend in life, got the ball rolling when he slandered the dead and defenseless writer in a biography, tagging Poe as a drunk, a madman and a reprobate, an image that still clings to the master of the macabre to this day.

Perhaps you have to be an artist yourself to appreciate the irony of the situation. Like Scott Fitzgerald down the road in Rockville, Poe left a myth that is bigger than his work—never a comfortable situation for any artist. More people recognize Poe the madman than Poe the writer.

I could see where Michael might identify with him. I know I do. Somehow, it seemed right and proper to go to Paca and Greene with one genius madman to pay respects to another one.

While there are older cemeteries in Baltimore, there are probably few as historic or atmospheric as Westminster. To my knowledge, no other site in the watershed has catacombs.

The original burial ground established on the outskirts of Baltimore in 1784 by the First Presbyterian Church was then known as Western Graveyard. Some of the most prominent Presbyterians of Baltimore were buried there in the oven vaults and pyramids that line the outside walls, or are laid out beneath the tabletop markers. Soldiers and merchants, as well as politicians and their families and servants, all rest here, including Poe's grandfather, the merchant David Poe, beside whom Edgar Allan was originally buried.

In 1850, following the passage of a law mandating that graveyards within the city limits must have a church on the property, First Presbyterian built a red-brick Victorian Gothic church on arches *over* the central part of the cemetery, creating a unique set of catacombs below. It is down here, in this creepy half-world below the building, that Frank roams free. Frank is the ghost of a body snatcher—a "resurrection man"—who once made his living plundering these tombs to supply corpses to medical schools, including, of course, Johns Hopkins. Anyway, that's the story.

During the War Between the States, Union troops occupied the building and used the steeple as a lookout. After the war,

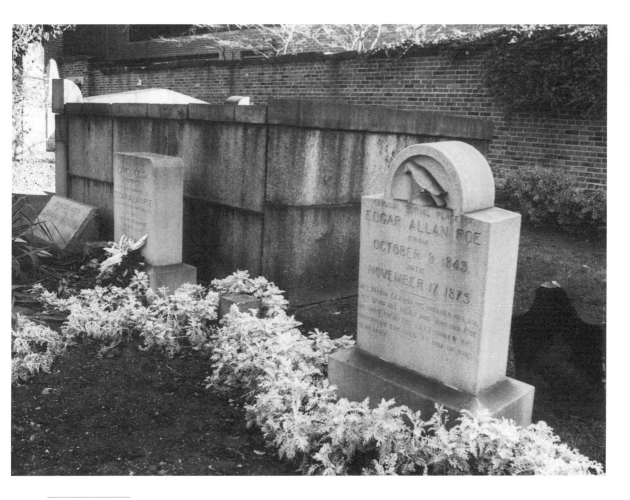

Edgar Allan Poe
grave, Baltimore,
Maryland

the once prosperous neighborhood began a steady decline.

The catacombs, which were open in those days, became crash pads for winos and derelicts, and the tombs and stones were vandalized or victimized by weather and neglect. The neighborhood children were said to use bones from the churchyard for toys.

By the 1960s, the burial ground was truly spooky; crumbling, overrun by brambles, weeds, and junkies. At least once, a fresh corpse turned up in an old tomb. The last religious service was held in 1977. Then, in the late 1970s, several historical and preservation groups, headed by Dean Michael Kelley of the University of Maryland Law School, created the Westminster Preservation Trust, and the property's restoration was begun. Today, the old church houses the *Maryland Law Review*, the Poe Society, and a variety of other community and civic groups.

Every year, on Poe's January birthday, a mysterious figure, dressed in black, leaves roses and a bottle of brandy at the grave, usually under the attentive eye of curious onlookers and the media.

Here lies a kind husband and father dear
It is God's will he should be here
We hope our loss
Will be his gain
And hoping heaven
He will obtain

—Robert Parsons (d. 1836),
near Deal, Maryland

It was almost dark by the time Michael and I parked the car, located a quasi-in-charge person, wandered around, and eventually found Poe's original grave behind the church. A soft, bitter snow had begun to fall as we walked through the silent cemetery, awed by the huge, crumbling vaults that towered over us and the sudden, unearthly quiet that cut us off from rush-hour Baltimore.

The vaults of the prominent and powerful dead are one of the other attractions that make this an interesting spot. One can see the necropolitan architecture of turn-of-the-eighteenth-century Baltimore here in granite and marble. Several are definitely neoclassical and at least one vault features an Egyptian motif that was popular for about three years following Bonaparte's conquest of the ancient kingdom. The brick and steel highrises surround this site like the walls of a canyon, giving it a dissonant, alien setting that sharpens the eerie ambience of the place.

A cat ran out from behind a tombstone and crossed our path.

"That's Poe's spirit," Michael said matter-of-factly. "He's not buried up front, he's buried back here, around behind the church." He meant that Poe still lay in his original grave—an unoriginal thought. Others have disputed whether or not the moved corpse was actually Poe's. But in the wind and the dusk, I believed him, wrapping myself tightly in my thin green coat, feeling the frozen ground beneath the soles of my flimsy black pumps, watching as Michael placed his painting on the tombstone that marked the place where Poe used to lie. There was a raven carved on it. That seemed appropriate for an empty grave. Or is it empty?

Just as he placed his painting on the tomb, the wind picked up; it became a high sustained wail, almost a whine, cutting through the silence.

We turned and ran, and we didn't stop until we were in the car heading for Fell's Point and hot coffee. So much for Mr. Poe.

In her excellent book, *The Very Quiet Baltimoreans*, Jane B. Wilson says that if one visits only one cemetery in Baltimore, it should be Westminster.

I agree.

Lord help my poor soul!
—*Edgar Allan Poe's last words*

Original Burial Place of
Edgar Allan Poe
from Oct. 9, 1849
until Nov. 17, 1985
Mrs. Marie Clemm, his mother-in-law
Lies upon his right, and Virginia Poe
his wife, upon his left, under the monument
erected to him in this cemetery

Arts and Crafts

◦❦◦

Now, I'm gonna tell you this story, and I swear it's true, because otherwise why would I tell it?

There's this woman, down the Shore, who was terrible big on all those craft projects, an arts-and-crafts type, and she had some money, because she was married to one of those businessmen they have down there.

Well, she built a house, and she went out and dug up and pried off and bought and heaven-knows-what all these old tombstones out of the fields and off the bayshore and the rivershore where they had washed overboard, and took 'em back to her house and laid 'em flat into her patio, just like you or I would lay brick!

Isn't that a common thing to do?

Besides, it gives me the cold shivers just to think about it, the old gravestones of all those dead people, moved away from the old cemeteries and used like that!

Oooh! I don't believe in ghosts, but I don't want to mess around with no dead people, either, you know?

Now, this is as true as I sit here, becuase I'm too dumb to lie. Besides, my cousin's husband's sister's married to the man who laid 'em in for her. She thought that was so clever and cute, paving up her patio with those old gravestones! Can you imagine anything tackier?

Well, she went on like that, and they even wrote a great big article about her, being so *creative* and all, in the local paper down there, like it was something clever.

But you and I know better, don't we? Not that I believe in ghosts, but can you believe that?

And wouldn't you know, that place, that house burned to the ground one night, and they never found out what caused it. Not a stick left!

She'll never have any peace, not till she takes those old tombstones back to where they belong, on top of those dead people they come from.

As you are now so once was I
I had my share of worldly care
As I was living as you are
But God from all has set me free
Prepare for death and follow me.

—Major Francis Turpin (d. 1829),
near Cambridge, Maryland

A Tribute to the Graveyard Mind

❦

I bow in admiration to the determined amateur historians and genealogists, most of them determined ladies of a certain age, who have tramped miles across rough fields and whacked through dense, tearing greenbriar and undergrowth in search of forgotten graveyards. They have braved snakes and mosquitoes and the wrath of property owners in their quest. They have scrubbed the faces of worn-down stones with wire brushes and sponges and painstakingly recorded the last details of lives long ago ended. They have preserved the forgotten dead for posterity. It's no easy job for young people, let alone older ladies, as I found out doing this book, and I was only looking for the more remarkable stones.

These ladies search for every last stone in the watershed and record what they find. They crawl through muddy fields and thick woods, over briars and brambles, without fear of snakes or other wildlife, on their quest to gather all the information from every marker they can locate.

Given that old age is not for sissies, these ladies who will never see fifty again demonstrate that sissies are not likely to cultivate the graveyard mind either. These women are a brave lot, and they brighten my view of my sunset years.

My hat is off to them. Heaven knows, I want to be one of them someday.

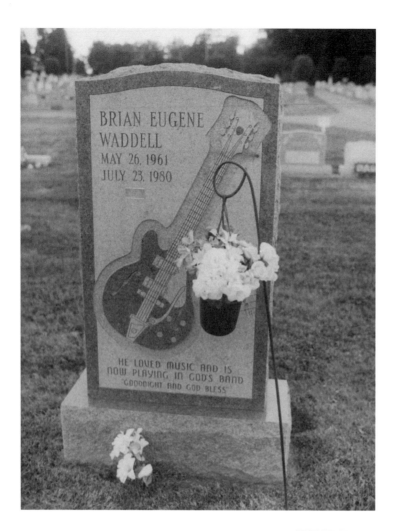

North East,
Maryland

There was this guy, and he picked up these two girls hitchhiking and they killed him and stole his van and drove to Ocean City before the cops caught them, or at least that's what I've always heard around here.

I guess he liked to play the guitar, because that's what the family chose to put on his tombstone. So they call him Guitarzan, after that old song.

You don't see that on a gravestone very often, do you?

Suggested Reading

Alexander, John. *Ghosts: Washington's Most Famous Ghost Stories.* Arlington, Va.: Washington Book Trading Co., 1988.

Allen, Henry. "The Other Side of Paradise." *Washington Post,* September 24, 1996.

Bodine, Aubrey. *Chesapeake Bay.* Cambridge, Md.: Tidewater Press, 1953.

———. *My Maryland.* Cambridge, Md.: Tidewater Press, 1955.

Bott, Robert. *Home Remedies for Man and Beast.* Nashville, Tenn., 1842.

Brugger, Robert J. *Maryland: A Middle Temperament.* Baltimore: Johns Hopkins University Press, 1993.

Coffin, Margaret. *Death in Early America.* New York: Nelson, 1976.

Exton, Peter, and Dorsey Klietz. *Milestones to Headstones.* McLean, Va.: EPM Publications, 1985.

Footner, Hulbert. *Rivers of the Eastern Shore.* Centreville, Md.: Tidewater Publishers, 1956.

Garrett, Elisabeth Donaghy. *At Home: The American Family 1750–1870.* New York: Abrams, 1993.

Gunn, John C., M.D. *Gunn's New Family Physician.* Louisville, Ky.: Moore Publishing Co., 1870.

Hume, Ivor Noel. *The Virginia Adventure.* New York: Knopf, 1994.

Iverson, Kenneth V., M.D. *Death to Dust.* Tucson, Ariz.: Galen Press, 1994.

Josephy, Alvin M., Jr. *500 Nations: An Illustrated History of North American Indians.* New York: Knopf, 1995.

Lancaster, Kent, and Mary Ann Hayward. *A Guide to the Burials and Markers 1775–1943.* Baltimore: Westminster Preservation Trust, Inc., 1984.

———. "Old St. Paul's Cemetery, Baltimore." *Maryland Historical Society Magazine,* vol. 78, no. 2 (Summer), 1983.

———. "On the Drama of Dying in Early Nineteenth Century Baltimore." *Maryland Historical Society Magazine*, vol. 81, no. 2 (Summer), 1986.

Lesy, Michael. *Wisconsin Death Trip.* New York: Pantheon, 1973.

McClellan, Elisabeth. *History of American Costume 1607–1870.* New York: Tudor Publishing Co., 1937.

Nelson, Robert F. *Thrilling Legends of Virginia.* Richmond, Va., 1971.

Roth, Hal. *Conversations in a Country Store.* Vienna, Md.: Nanticoke Press, 1995.

Smedly, Rickart Taylor. "Samuel Pepys of the Old Plantation." *American Heritage*, vol. 4, no. 3, 1959.

Smith, John (Captain), ed. Karen Ordal Kupperman. *A Select Edition of His Writings.* Chapel Hill, N.C.: Institute of Early American Culture, University of North Carolina Press, 1988.

Taylor, R. L. *The Ghosts of Tidewater Virginia.* Williamsburg, Va., 1996. Published by author.

Twain, Mark, ed. Victor Doyno. *Adventures of Huckleberry Finn: The Only Comprehensive Edition.* New York: Random House, 1994.

Wallis, Charles L. *Stories in Stone.* New York: Oxford University Press, 1954.

Wilson, Charles Reagan, and William Ferris, eds. *Encyclopedia of Southern Culture.* Chapel Hill, N.C.: University of North Carolina Press, 1990.

Wilson, Jane B. *The Very Quiet Baltimoreans.* Shippensburg, Pa.: White Mane Publishing, 1991.

Wilstach, Paul. *Tidewater Maryland and Environs.* New York: Bobbs Merrill, 1936.

UNPUBLISHED SOURCES

Dare, George S., M.D. Account books, ca. 1886–1888.

Doby, Kimberly. *The Famous People Buried at Greenmount [sic] Cemetery.* Unpublished manuscript, Dundalk Community College, 1996.

Gerhardt, Mrs. Simon P. *My Recollections of Tidewater Virginia and Its Glorious History.* Undated (ca. 1950).

Johnson, Arvel. Dorchester/Wicomico Oral and Undocumented History Project. 1994.

Lancaster, Kent. Notes from various lectures. Undated.

Simon, Janet. Diaries and correspondence, ca. 1934–49.

Paul Allen, Karen Basile, Reuben Becker, Amy E. Brown, Gloria A. Brown, Judith D. Brown, Robert E. Brown, Beebe Henderson Castro, Jack Castro, Arline Chase, Dr. Charles Cippola, Betty and Calvin Cummings, Edward and Rosemary Dean, Jan Elmy, Rev. Ella Trott Everett, Rev. Mary Ann Farnell, Irma S. Harper, Imogene Horton, Tom Horton, Jean Jenkins, Rev. Joyce Jenkins, Arvel Johnson, David Lawrence, John Lewis, Johnny Marshall, Etta Miller, Anne Moore, Lillian Mortimer, Daniel Murphy, Edwina Murphy, Randolph Murphy, Kristine Neaton, Scotti Oliver, Marian Ostrowski, Chris Parks, Marian Quick, Hal Roth, Raymond Seth, Jackie Stork, Roland Taylor, Bill Tubbs, Terry L. White, Petey Willis.

Columnist, recovering reporter, and writer of books, **Helen Chappell** has covered Chesapeake Bay's Eastern Shore for a variety of publications including the *Washington Post* and the *Baltimore Sun*. Her work has received grants from the Maryland State Arts Council and the Sumner T. McKnight Foundation. Her journalism was recognized with the A. E. Emmart Award for Excellence in Writng on the Humanities in Maryland. Chappell is the creator of the Hollis Ball mystery series and the Oysterback stories. She lives near Easton, Maryland, where she tries to keep a low profile.

Starke Jett V received a B.A. from the College of William and Mary and studied photography at the Rhode Island School of Design and at the Brooks Institute of Photographic Arts and Sciences in Santa Barbara, California. In 1991 and 1992, he worked on a project documenting the watermen of the Northern Neck of Virginia in association with the Reedville Fisherman's Museum and the Virginia Foundation for the Humanities. Currently living in Reedville, Virginia, he does freelance editorial work for several publications, including *Chesapeake Bay, Soundings,* and *Wooden Boat,* and has been published internationally in England's *Classic Boat* magazine. His work has won special awards for excellence from, among others, the Virginia Press Association, the Virginia News Photographers Association, and the International Regional Magazine Association.

Library of Congress Cataloging-in-Publication Data

Chappell, Helen, 1947–
 The Chesapeake book of the dead : tombstones, epi-
taphs, histories, reflections, and oddments of the region /
by Helen Chappell : photographs by Starke Jett V.
 p. cm.
 Includes bibiographical references (p.).
 ISBN 0-8018-6041-5 (alk. paper)
 1. Chesapeake Bay Region (Md. and Va.)—Social life
and customs. 2. Chesapeake Bay Region (Md. and Va.)
—History—Anecdotes. 3. Chesapeake Bay Region (Md.
and Va.)—Genealogy. 4. Cemeteries—Chesapeake Bay
Region (Md. and Va.) I. Title.
F187.C5C42 1999 98-36625
975.5'18—dc21 CIP